MW00803300

TROPE

TROPE PUBLISHING Co.

WEEDS

ESTD
SINCE
1963

WEEDS TAVERN

POSTER
ART
◇BY◇
SERGIO
MAYORA

WEEDS

ESTD
SINCE
1963

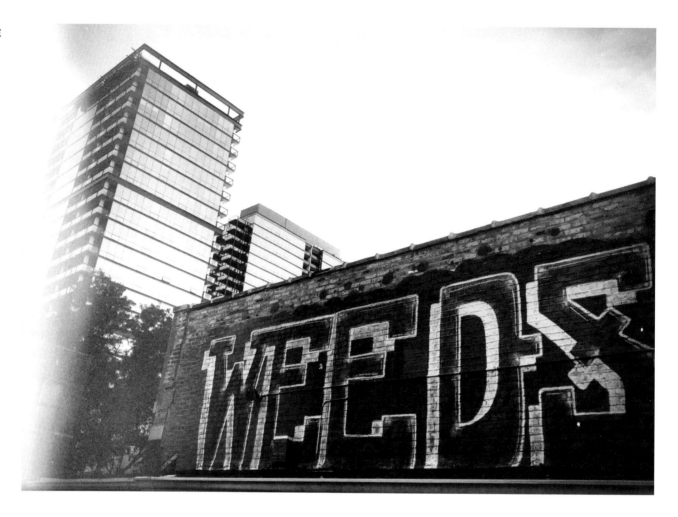

I've known Sergio Mayora a long time. Not as long as most, but long enough. Like most people, I met him when he was bartending at Weeds Tavern. My first impression was, well, I was intimidated. I assumed he didn't like me very much so I would just watch him from afar. Not like I was in love with him or something because I'm not. He's just one of those people who is mysterious enough to command your attention. You wanna know what he's thinking, y'know?

And boy, is he thinking!! Once he finally opens up, there's no end to the thoughts and opinions Sergio has in store for you, filtered through and shaped by one of the most unique personalities I've ever encountered.

And to top it all off, the guy makes music! And poetry!! And art!!! That first time in Weeds, the thing that made the biggest impression on me besides the Mexican Sasquatch behind the bar was the posters. They made you feel like you were in a special place. An exciting place, the epicenter of some sort of movement like maybe the next incarnation of Allen Ginsburg or Che Guevara or Charles Bukowski might come stumbling through the door.

A basic, probably over-simplistic, definition of what makes an artist great is that when you see their work you know it's their work. You don't need to check the signature in the corner. Sergio's work does that. Not only because his style is so specific but also because his very spirit radiates from the colors, lines, shapes and images he employs.

I live in New York City now. The wild nights at Weeds are a thing of the past. Now I go to museums for fun. The other afternoon I went to the Whitney to see the Edward Hopper exhibit. Then I checked out the house collection for a bit. The Whitney is devoted to American Art and they don't have a single Sergio Mayora!!! Heresy!!! Time for another curator!!

Maybe they're intimidated...

Michael Shannon

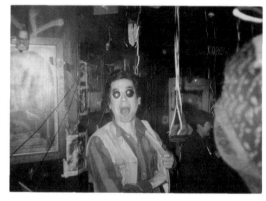

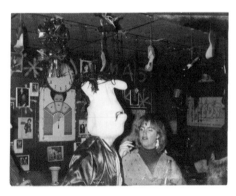

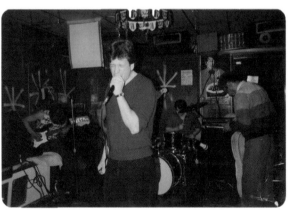

SERGIO MAYORA STORY

BY

DAVE HOEKSTRA

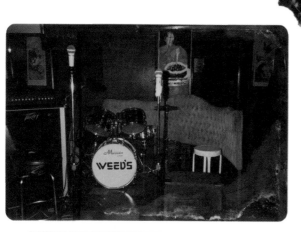

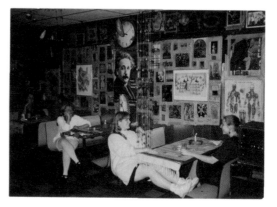

The Near North Side neighborhood tavern Weeds has been a garden of cultural delights. It was a cornerstone of Chicago's poetry scene. It was the site of historic Thursday night jazz sessions featuring Louis Armstrong's drummer Barrett Deems, vibraphonist Carl Leukaufe, bassist John Bany and others. The Bedbugs trekked up from the east side of Chicago to play sweet pop and rock music at Weeds. Actor John Cusack tended bar at Weeds and Jamie Lee Curtis once drank tequila there. Now a gritty sports bar, Weeds is the template for the popular Hideout music club only a few blocks north.

And there was Weeds bartender-host Sergio Mayora. He is an artist, poet, singer-songwriter, and actor. In 1970 he played the role of Indio in the Gordon Tech High School production of *West Side Story*. Always clad in blue overalls, Sergio wears dark glasses even in the dead of the night. He knows all the words to the De Castro Sisters' 1954 love song, "Teach Me Tonight."

He is a friend of mine.

He won't like me telling the story about us sharing a bottle of tequila in a hot tub before an April 1991 Texas Tornados concert at the Star Plaza Theater in Merrillville, Indiana. We kept our clothes on. A large group of us rented a double suite at the hotel. Sergio also wrote a story for an underground newspaper about how he met Freddy Fender of the Texas Tornados after the concert. That was "Fake News." Sergio was ahead of his time.

A life-sized painted bust of Sergio clutching a bottle of tequila once greeted customers at Weeds. It now sits like a king searching for his court atop a front-room mantle in Waukegan, Illinois. Weeds is an old, heartfelt bar. It opened in 1963 as the 1555 Club. Before that it was a children's furniture store. The 1555 Club was a hangout for workers from the long-shuttered Seeburg jukebox factory down the street. Sergio's uncle Paul and his family bought the club in 1983. It morphed into Weeds because it was at the corner of Dayton and Weed streets.

Sergio started as a Weeds cook, filling in for an aunt who left for Mexico. He liked to add sweet beets to his homemade hot sauce. Sergio's mother was from Aguascalientes, near Mexico City. His father was from Mexico City. I first walked into Weeds in the winter of 1985 and was impressed by the room's steamy diversity. The bar often consisted of people from the Cabrini-Green projects as well as the tony Sandburg Village apartments. There were hillbillies and flight attendants. People hung bras and condoms above the bar and Sergio decorated the tavern with artwork he found in North Side dumpsters.

And then Sergio began creating his collage posters to promote the club. They are singular cut-and-paste works of art.

"I don't look at it as art," Sergio says over beef and rice soup at a North Side taco store. "Not at all. I gotta be careful. I look at it as language. Maybe it sounds stupid, but it is my language. I know it has artistic stuff in there. It's collage."

Sergio has doused his soup with gobs of salt, like stars falling from the heavens. That is sort of how he has lived his life. Straight shot and no chaser. He turned 70 years old on July 14, 2023.

He also writes poetry and songs, he paints spirit boxes and has dabbled in acting. Sergio has a catalog of about 20 paper notebooks filled with art and words. He tries to keep the words private. "I want to share," he says. "People will get them when I'm gone."

That thought is written into the future. Many of his posters predicted the world we are living in today:

- "Weed's Pollution Night" (1988), depicting a guy in a face mask dealing with global warming.

- "Making America Safe in the War Against Censorship" (2004), promoting a poetry night.

- "Birth Control Day" (1986), celebrating "masculinity and femininity," according to Sergio back then.

- "Transvestite Nite" (2000), honoring "ordinary men with extraordinary courage to wear dresses." That evening Weeds also promised "the world's only cross-dressing live band. No cover."

Now Sergio explains, "I did not know what business meant and zilch about advertising. But I reckoned it should be intriguing, friendly and forget the bottom line. If you want people to come somewhere you offer something they are missing. Other bars had ferns and phony sitcom store-bought decor. We didn't."

Sergio pauses for a moment and rearranges his thoughts. "Well, we did," he says. "But we got it (decor) after others threw it out just because it was a broken has-been. Not me. I see an

opportunity. Those rough misspelled posters were a scream to anyone out there to come and see the spirit that can reside at any location if one makes business the second priority and spiritual comfort number one. I'm an old farmer of concepts. That's why I wear overalls. I plant ideas."

His work has been shown at the Ukrainian Institute of Modern Art, the Citlalin Gallery Theater and he made a knockdown circus doll for an auction at the INTUIT (The Center for Intuitive and Outsider Art) gallery in Chicago. He taught kids at the Casa Juan Diego Youth Center in Pilsen how to make spirit boxes.

Marla Donato is a Chicago-based journalist. She was a staff writer at the *Chicago Tribune* from the 1980s through 2002. She wrote about Weeds for the *Tribune* at the same time I was writing about Weeds for the *Chicago Sun-Times*. She also taught humanities art at Columbia College and brought in Sergio to speak to her students.

"His posters were very interesting," she says. "It's easy to make a collage but it's hard to make a good collage. The posters are very vibrant. He creates this fantastical world that uses geometric shapes and primordial figures that are sometimes reminiscent of Chichen Itza (the alien city in the Maya lowlands). The shapes and compositions manage to meld the ancient world with the futuristic cosmic. He seems to channel Chichen Itza where aliens came down (50,000 years ago according to Sergio). His work captures my imagination." It is fitting that Sergio resides in Waukegan, the birthplace of science fiction writer Ray Bradbury, who wrote *The Martian Chronicles* and *Something Wicked This Way Comes.*

Scott "Squat" Levy is a business consultant and music producer based in San Antonio. He became a Weeds regular in 1988 after several trips to Chicago from Detroit while consulting for the Ford Motor Company. He was part of the Weeds community until 1998 and moved to Santa Fe in 2003. In December 1998, Squat organized a "Death Party" for Sergio because of his ailing health. Squat is also friends with Manuel Cuevas, the acclaimed Mexican fashion designer who made historic garments for Gram Parsons, Bob Dylan, Dolly Parton, and others. In 2009-10 Squat had his music studio in the basement of Manuel's Nashville shop.

"Manuel and Sergio, both high-level thinkers," Squat says in a thoughtful conversation from Texas. "They use a lot of vibrant colors. There's intricacies in the designs. There's always deep themes. When you look at Manuel's work and you look at Sergio's work, it's what you see at a glance. Then there's the second look and you see something different. Then the third glance presents another meaning. That's true with Sergio's posters and boxes. Manuel has one of Sergio's boxes. It has a cassette tape inside with some (Sergio) song on it. The two of them have never met. There's a possibility that could happen."

Manuel is designing a bridge that will cross a creek on his property outside of Nashville.

Squat and Manuel have been talking about making the bridge out of empty tequila bottles. "Sergio said he could do that," Squat says. Sergio says he can do that, too.

Squat met Manuel through Larry Weiss, one of his longtime clients. Weiss wrote the Glen Campbell hit "Rhinestone Cowboy" and co-wrote "Bend Me, Shape Me" for Chicago's The American Breed. Squat's other clients include Edsel Ford II of the Ford Motor Company and Bob Doyle, the manager for Garth Brooks.

Acclaimed Chicago poet Gregorio Gomez became the host of the Weeds poetry night in 1987 which ran until 2016. The former managing director of the Latino Chicago Theater Company in Wicker Park also hosted a successful Weeds poetry night reunion in the summer of 2021.

"Those posters served two purposes," Gomez says. "One, to entice the novice to come and explore the night church of Weeds. The posters had some kind of religious component. Second, it was legendary literary shit Sergio would write on those things. He seemed to be ahead of his time. People collected those posters because they looked at it from an artistic perspective. He gave a lot of them away. I used to have ten, fifteen but they perished in the (theater company) fire. It was limited advertisement. It was more for pleasure in that he was able to show the world what he was doing—artistically and philosophically. Whether he knew it or not, that's what he was doing."

Sergio moved ahead of his place in time.

"He did underwear night before Madonna," Donato points out. "He was encouraging people to put their underwear on top of their clothes. Right? He told me a lot of people he saw in Weeds were very closed-in. He wanted to bring their insides out. He decided to do that by having underwear night so maybe they'd come out of their shells. Sometimes the biggest censors we have are ourselves. He doesn't censor himself. He doesn't worry about it, which is one of his endearing and frustrating qualities. There's a Buddhist concept where you can hold two opposing concepts in the same space. Where it's not this or that, it's this and that. He does that in his approach to things."

Richie Ponce is a retired Union Pacific freight train conductor who lives in suburban Westmont. He is Sergio's first cousin. His mother, Sergio's mother, and Uncle Paul were brothers and sisters. Richie helped Sergio light the kinetic incense-soaked fire that became Weeds. "We were open every day," he says. "The jukebox factory closed down and the other factories around there started folding. My uncle wasn't getting any business. Cabrini-Green was there." Richie's mother Alga was the cook at Weeds and Sergio was brought on board to help in the small kitchen. He had been a cook making $17 for a 40-hour work week at a Mexican restaurant.

"Well, it got real busy," Richie says. "Sergio started making posters. We'd go to Old Town and stick them on light poles. Sergio has been doing art since he was a kid. He liked abstract

art. Right out of his mind all this drawing all the time. We'd ask, 'Where do you come up with this?' Weeds got popular. Sergio started doing theme nights on weekends. Water night, fights with water guns. Pajama night.

"People came in lingerie. We had Indian rugs with candles on a table at the front of the bar as you walked in. Sergio would stand outside singing. You couldn't do this stuff today.

"Gayle (Ryan, a close friend of Sergio's) started videotaping customers. Bands started coming in. The band Rico!, that's where they got their start. There was a guy named Cleo (Patrick) who played great Jimi Hendrix songs. He looked like Jimi Hendrix. At first Sergio worked the door and I bartended. He later bartended when it got busy."

Ryan was warm and super-friendly. She was a Chicago Public School special education teacher for 38 years. She was a smooth tonic for nervous customers entering the dive bar for the first time. On weekends between 1985 and 1988 she stood on a wobbly metal crate by the front door with a handheld camera and videotaped the weedy bacchanal. "We didn't have a tripod," says Ryan, now retired and living in Florida. "It was a heavy camera. I'd shoot the bands then turn around and shoot the crowd. Sometimes it wasn't a good thing. A guy might be there with a girl on tape and it turned out he was married." Sergio has a library of nearly a hundred VCR Weeds tapes stashed away in a dresser at his Waukegan crib.

Sergio credits Ryan for connecting Weeds with the "local natives," as he puts it. Between 1977 and 1979 Ryan was a bartender at the Old Town Ale House on the Near North Side, where she met Sergio. "It might have been the first time he went to the Ale House," she says. Ryan knew the regulars at the Ale House and O'Rourke's, at both its North Avenue location and later at its final spot just a couple blocks north of Weeds on Halsted Street.

On a good night people would hit Weeds, O'Rourke's and the Ale House. John Cusack and his sister Joan wandered off to Weeds a couple of times because John was friends with Jay Kovar, the late owner of O'Rourke's. Ryan knew Kovar. Chicago trader Bill Plummer brought Jamie Lee Curtis into Weeds. "Very tall dude," Sergio recalls. "Raincoat. Rolls Royce. The works. Bill got married, had kids, and moved to Montana. He had a 1000-acre cow land in Texas. He once invited me to go to Texas, get on a helicopter and hunt cougars. I told him that shit is no part of me."

Ryan says, "Sergio is amazing for what he did. The posters! He made a special poster every month for an event. He would do the posters all day when I taught. Then we'd go run them off at Kinko's at night. Sometimes we slept on the pool table at Weeds. It was a good time."

Donato adds, "He would put together these elaborate posters—and this was before glue-stick—he would tape things onto the posters. Then he would Xerox them and go to Kinko's. They'd run these things off and sometimes you could see the bits where the tape was on the

poster. That was some of the charm of it. It was a raw, sophisticated design. His artwork, his posters, his thought process are such an interesting mix. I was in the (*Tribune*) fashion section for a while. The combination of his colors are really quite remarkable."

Sergio retired from Weeds around 2014. The bar remains in the family, now managed and operated by John Martinez, a 45-year-old son of Uncle Paul. John remodeled and deep-cleaned the bar. He removed the bras and condoms. Sergio's posters still hang on a north wall. Several Weeds customers refer to the establishment as a sports bar and indeed sports are presented on five television sets and one in the beer garden. Live music is occasionally booked, but Weeds is so unconventional it doesn't have a website. Martinez can be seen in the morning at Weeds cleaning up the alley adjacent to the bar. He has a low-profile persona, quite the opposite of Sergio. "I'm very quiet and I don't like people to know what I'm doing," he says during an interview in the Weeds beer garden. "I'm a humble guy. I keep things to myself. My Dad had a stroke and that's when I started coming around more often to help out." At the time he was working with Section 8 housing in the neighborhood.

Sergio has dealt with health issues in recent years. He had a heart attack in the 1990s followed by open-heart surgery in 2015. These events have slowed down his nightlife exploits. He has downsized his drinking. Sometimes he sings at a Chicago art gallery. He still makes an occasional appearance at the Old Town Ale House, where a Bruce Elliott color portrait of Sergio hangs near the bar. Elliott owns the Ale House. Unlike some of Elliott's other bar paintings, Sergio has his clothes on.

Sergio's orbit is so large because he is not uptight like so many Americans today. He likes life's bright colors. His sight might be fading, but he still views life with wide eyes.

Sergio's parents took him to Mexico to live with his grandmother until he started school. He came to Chicago and grew up around Polk and California. He drew daily as a child. Sergio once told me he stopped drawing in his twenties because he thought his art was silly. "I was embarrassed," he says. "But later on, I realized it didn't matter. If I draw a stick figure, it's important I drew that stick figure and you didn't. When you draw your stick figure, come tell me about it."

And thousands of Weeds passengers have been along for the memorable journey.

Susann Craig was one of Chicago's most notable art collectors. She taught art at Columbia College, directed The Dorothy Rosenthal Gallery and operated many galleries and shops. Craig was a founder of INTUIT (The Center for Intuitive and Outsider Art) in Chicago. She was a passionate champion of Sergio's work. Craig died on June 28, 2021, from complications of breast cancer in Santa Monica, California. She was 84. Her ashes rest in one of Sergio's boxes.

Her last request was to hear Sergio sing the Stephen Foster ballad "Oh! Susanna" over the phone.

Craig had met Sergio at Weeds. I remember Craig being a semi-regular at the Thursday night jazz sessions. "My mom was a curator of all things cool," says Craig's daughter Amy Coleman, who grew up in Chicago. "She knew the best bars in every town. The most interesting people and most interesting stories are what she was looking for. It didn't have to be fancy. She loved to talk to journalists, authors, poets and artists. She considered Sergio to be one of her closest friends. She was a champion of the people she believed in. She believed in him not only as a visual artist but she thought he was a brilliant poet. I know they drove each other nuts at times but she found him incredibly interesting."

Sergio reflects, "I would call Susann Craig once or twice a week. When she didn't answer I would sing. Later I said, 'Why don't you answer the phone?' She said, 'When I don't answer you always leave me a little song. I like hearing them.' That's how that started."

The Weeds Monday night poetry night gave a special forum to voices of color in the mid-1980s. Blacks and Latinos found a friendly groove for their craft. The late Black poet Joffre Stewart was a Weeds regular on nights beyond poetry night. Stewart was reserved and guarded but would be proud to show a customer how he was featured in Allen Ginsberg's "Howl." Stewart carried the Ginsberg story-poem with him to prove his point.

The Weeds poems could be poignant, offensive and everything in between. In 1985, the late White Panther Party propaganda minister Bob "Righteous" Rudnick had approached Sergio about conducting literary "bouts" on the small stage at the north end of the bar. Early poets were the outside scat-soul singer Thurman ("Hello Lucille, Are You a Lesbian?") Valentine and Marc Smith, who went on to create the Green Mill Poetry Slam.

 "One of the poets told me about this crazy place called Weeds," Gomez says. "I checked it out and that's when I met Bob Rudnick. He was a wild character and he was doing his poetry. There was a light bulb and a lamp. Not even a microphone. The poetry was sporadic because Rudnick and John Sinclair (activist, poet and manager of the rock band MC5) went back and forth from Chicago to Detroit."

"Weeds was a place that was free from commercialism," explains Gomez, who was living in Wicker Park during the Weeds heyday. "We were a refuge for the hundreds of poets who were skewed from the ordinary language. That's how I created the Erotica Exotica Poetry Night. It was an anti-Valentine's Day thing. It attracted political people, including women. It was the urban alternative to the commercial alternative. We were late-night. We were rambunctious. People were offended. The things we were doing at that time we could not do today. We were ragtag Galactica going through the avenues of the mind. We were the only place that had hecklers with knowledge. The poets heckled back."

One Weeds poet included J.J. Jameson (Norman Porter, Jr.) who had been published by

Puddin'head Press in Chicago. He was also a prison escapee. Porter had pleaded guilty to charges of second-degree murder in the 1960 shooting of a part-time clothing-store clerk in Massachusetts. Porter was on the lam as Jameson until 2005. A police officer saw his picture as "Poet of the Month" on ChicagoPoetry.com.

Gomez says, "We were a group of actors who didn't take literature from the schools but our experience from the streets. We were not a 'poetry slam.' We were the longest-running underground literary venue with a hard edge. Who were those hard-edged urbanites? Blacks. Latinos. The girls that came in, they were hardcore poets. Poets liked the fact I treated them with respect and equality. That's one of the reasons I never had a featured poet. Every other venue had 'featured poets.' I treated everyone the same. We were all published in the air. And Weeds literally became a literary learning university. People would try out their work. I was like the headmaster. But it was the poets who came every Monday that challenged me to do better. They challenged me as a host. They challenged me as a writer. Weeds was not a place to hang.

"Weeds was a stepping-stone toward tomorrow."

Weeds is a template for the Hideout, the nationally recognized live music club and cultural center north of Weeds. Like Weeds, the Hideout is a small, family-run bar in a legacy industrial neighborhood surrounded by gentrification. I remember sitting with future Hideout owners Tim and Katie Tuten in the late 1980s at Weeds when they talked about opening their own place—just like Weeds. They had their eyes on the Hideout, a blue-collar joint that opened in 1934. Katie's father was a regular in the space that was built by Irish laborers in 1919.

During the late 1980s Tim was teaching U.S. and African American history at a high school in the Weeds neighborhood. "I came here on Thursdays for the jazz," he says. "Once in a while for Gregorio's poetry night. All the stuff Sergio used to do, 'Kennedy Assassination Night,' Jazz. Poetry. When we started, our calendar had all kinds of crazy stuff on it. It was influenced by Weeds. I used to joke at the Hideout, we want to be Weeds West. But also want to be like FitzGerald's East. And some of Lounge Ax." One of Sergio's cousins even gave Tuten a so-you-want-to-run-a-bar book. Tuten filled the book with detailed Post-it notes. Tuten also collected Sergio's Weeds posters. He still has a bunch of them.

Weeds is now surrounded by high-rise condo buildings, Crate & Barrel, Starbucks, Dick's Sporting Goods, and a nearby Apple store. John Martinez says, "People offer to buy this and I always tell them to fuck off. There are generations of family here."

Martinez made the aesthetic changes at Weeds little by little. "The city wants you to change stuff," says Martinez. "We have daycare down the street. The British school came in. It's not factories no more. Cars would be smashed in on North Avenue. Hookers were around. Now you can walk around here. This remains a family business. Everything you see here, we built by hand. The soul of the bar still exists."

"Change is a very hard thing to do," Tuten says. "People that came here 20, 30 years ago are like, 'Where's the bras on the ceiling? Why is it so clean? Where's the incense?' Because there's building codes. And we get shut down for that. And times move on. Things that used to be acceptable in the 1980s, like 'Dress Up Like a Bitch Night'—and I came in second place after Sergio—those things are considered inappropriate. You have to have cocktails for younger people now. These places were shot and a beer. Young people now want a Tito's and soda with a splash of Red Bull. Ten years ago it was 'Fuck no, go somewhere else.' They want a craft cocktail for $12. We wouldn't pay it." In the late 1980s and 1990s a bottle of Corona and a shot of cheap tequila was as fancy as Weeds got. Martinez says that today the top-selling beers are Modelo, Old Style and Pabst Blue Ribbon.

Weeds was hit during the 1968 Dr. Martin Luther King riots. Martinez was on guard during the May 2020 George Floyd murder protests. "I was sitting here barbecuing, making arrachera," he says. "Everything got boarded up. My neighbors love me. They didn't do any damage here because I was here. The cops called this station one. They'd check out what was going on. People were scared of my dogs. I got big dogs, no little shit dogs. I've got a Boerboel, the largest and strongest Mastador dog in the world. It weighs 220 pounds. And I had two pit bulls at that time. And a Cane Corso (guard dog)."

In April 1989 Sergio made a poster that said, "When Stress Closes In On You Relax!" It was part of his mantra when he made an unsuccessful run for Mayor of Chicago. In loud lettering he claimed to be "A Candidate for the Most Overlooked People in the Country—Lazy People!"

Sometimes the colors fade to blue.

On May 30, 2021, Sergio's mother Anna Mayora died in Chicago. She was 87. The Szykowny Funeral Home obituary reports she was survived by four children (including Sergio), 14 grandchildren and 13 great-grandchildren. She was preceded in death by her husband, Sergio.

The senior Sergio worked at the Joseph T. Ryerson steel factory on the South Side. He lost two fingers in two separate accidents on the factory line. After graduating from Gordon Tech, the younger Sergio worked at Ryerson for three years as a stockman and loading trucks.

Sergio's father taught him to cook which opened the doors for his Weeds life. He makes a mean nopalitos salad and shared his secret recipe with Donato. He is proud of his vegetarian enchiladas. He once made "Weeds American Hot Sauce" and sold it at the bar. "Taste is a skill one cannot easily attain when learning how to cook," he says. "Many cookbooks show great-looking dishes but taste like zilch compared to other dishes that are geared to addict you to tastiness. So I started cooking at the 1555 Club. By that time I was paying to work there just to sleep on the pool table. I wasn't making enough money to get my own place. I was partially bartending anyway so I just became a bartender there."

Sergio's defiant underdog streak is not lost on Los Angeles filmmaker Jeremiah Hammerling. In 2019 he began work on a Sergio documentary with the working title of "I'm Alive." The animated lettering on the film's title card is inspired by Sergio's poster design. The film features actors Michael Shannon, Hannibal Buress, Mark Vallarta, Chicago singer-songwriter Ike Reilly and of course Sergio. Buress used to hang out at Weeds while playing the bowling machine.

The rough storyline deals with Sergio's health issues and the assumption he is going to die. The theme is based on Squat's real-life "Death Party" for Sergio that he organized and paid for at Pops for Champagne. "Sergio's been on his last legs for the last twenty years," Squat says.

And Sergio is still alive.

He works in his basement studio, surrounded by more than 300 books with crayon, marker and pencil drawings and dozens of detailed journals. There's also reference books like the *Reader's Digest Book of Facts* and *Act of Creation: The Founding of the United Nations.* Occasionally he burns incense while working.

Sergio leans over a desk and pulls out one of his journals. He looks at an essay titled "For Goodness Grace." In elegant cursive Sergio wrote, "The only thing left to do is to leave whatever is left undone, alone. This may be more difficult than I had anticipated. In which case if I succeed the sacrifice shall bestow grace on me or so I feel. Then again what a waste considering we're all born with enough grace to last 10 lifetimes. Or are we? I just hope we can all walk out with just as much grace as we walked in with. For goodness sake anyway." He signed it 'Serf.'

"In my mind I'm a serf," he says. "Someday someone will wonder what one serf is thinking about. Some people think the word 'serf' is not smart. I'm not stupid."

Hammerling is a graduate of Columbia College Chicago and an alumnus of Werner Herzog's Rogue Film School. In the mid-2000s he lived near Weeds in a loft above a North Clybourn storefront. "The back of our apartment overlooked the Weeds beer garden," he says. "This was long before the Apple store moved in across the street. It didn't take long before we became close with John Martinez and Sergio. You would see Sergio at open mics across the city, holding court and making people laugh all over town. At that time I was just getting out of film school at Columbia."

Hammerling started filming Sergio's performances across Chicago. He wanted to capture Sergio's mystique. "Here's this intimidating-looking guy in overalls with a long ponytail and dark sunglasses," he says. "And then he starts to read poetry and he's got this booming soulful voice along with a sharp sense of humor. There was a sense he had broken the rules of reality to fit his image of the world.

"I was intrigued by the layers. The bartender, the poet, the musician, the posters, the spirit box creator. And eventually I started to hear stories from others and saw I wasn't the only one who felt this way. Don't get me wrong. Sergio is no saint. But he did and still does have a real gravitas that has commanded a lot of respect from people of all walks of life. People respected his opinion because he didn't mince words and he didn't change how he felt based on who he was talking to. It's hard not to respect someone who doesn't waver in their opinions. Especially someone who more often than not was going to bend over backwards to come to your aid if you were in trouble."

Squat adds, "I've met a lot of characters in my life. He's a character unlike none I've met before. There's a lot of people who are unusual but they're full of shit. What you see on the surface with Sergio is nothing like what you see when you go deeper. A lot of people are like, 'He swills tequila, I see him at the Ale House,' and all that. That man is extremely intelligent and he sees the world in the way it really is. And it's not the way we've been trained to perceive it."

Marla Donato has kept in touch with Sergio over the years. Her consistent belief is that Sergio's art is a reflection of how he is thinking and what he is visualizing. "When you meet him, he seems very basic," she says. "How do I say this? Underneath it there's multi-layers of thinking. He puts together these incongruent elements and somehow makes them work. It also speaks to how he sees multi-layers in the world."

The eclectic musical vibe of Weeds plays on through the popular Chicago-based Latin rock-soul band Rico! The band coalesced at Weeds in 1989 and 1990. Rico's founder-guitarist-vocalist Ricky Baker heard about Weeds from Lindell Thurmond, a funky bassist at the Kingston Mines blues club. Thurmond knew Cleo Patrick, the outrageous blues-rock player who was in Weeds' regular rotation. Thurmond brought Baker to an open jam night. Baker had just arrived in Chicago after playing minor-league baseball in the Cubs and Cleveland systems. He attended San Francisco State on a baseball scholarship. Rico! was formed in 1991.

"Weeds was a place where you could let your hair down and do anything you wanted musically," Baker says. "I would go there just to be creative spontaneously with certain musicians. I learned about other musicians in Chicago and that's how Rico! started. Sergio would ask us to do a gig here and there at the bar. Sergio was the man that kept it together and he was a great host. He was interesting. I liked his art and the artiness of the bar. It was sad when Sergio wasn't doing that anymore. I never revisited after that.

"There was nothing like Weeds."

Hammerling saw how the unique Weeds vibe informed Sergio's persona. "While Sergio never owned the bar, for a while he became synonymous with it," he explains. "It was interesting to use Weeds as a jumping-off point to explore Sergio's life and the people in it. And in some

ways it is becoming a film about mortality and what it means to be alive in the first place. Which is where the working title ('I'm Alive') came from. Any time you'd bump into Sergio on the street or in the bar and ask him how he's doing, he'd say 'I'm alive.' That's a reminder that despite how much things have changed in our lives, we're still here."

And just like its namesake, the neighborhood tavern Weeds won't go away.

Although the characters and craziness have moved on to an undiscovered garden, there is still a certain audacity about a tiny family bar throwing back cheap drinks in a neighborhood defined by fancy condos and chain stores. Richie says, "Everybody around there is high-class now. And then there's little Weeds. I mean it's been there for almost 60 years. I remember being 13 and watching my grandmother cook burgers and chili. I'd take the food to the metal shop and the jukebox factory across the street."

Sergio Mayora, his family and cast of urban characters delivered the goods that made Weeds one of the most important taverns in this city's history.

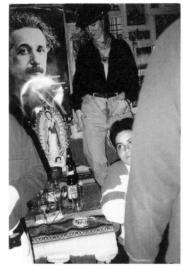

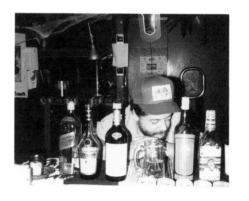

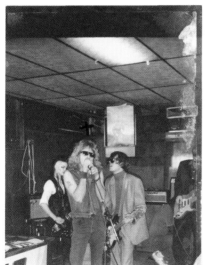

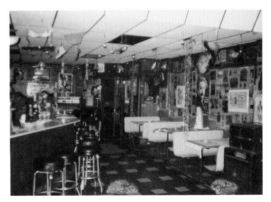

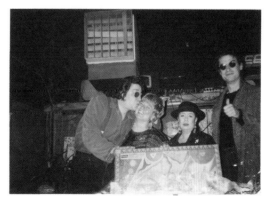

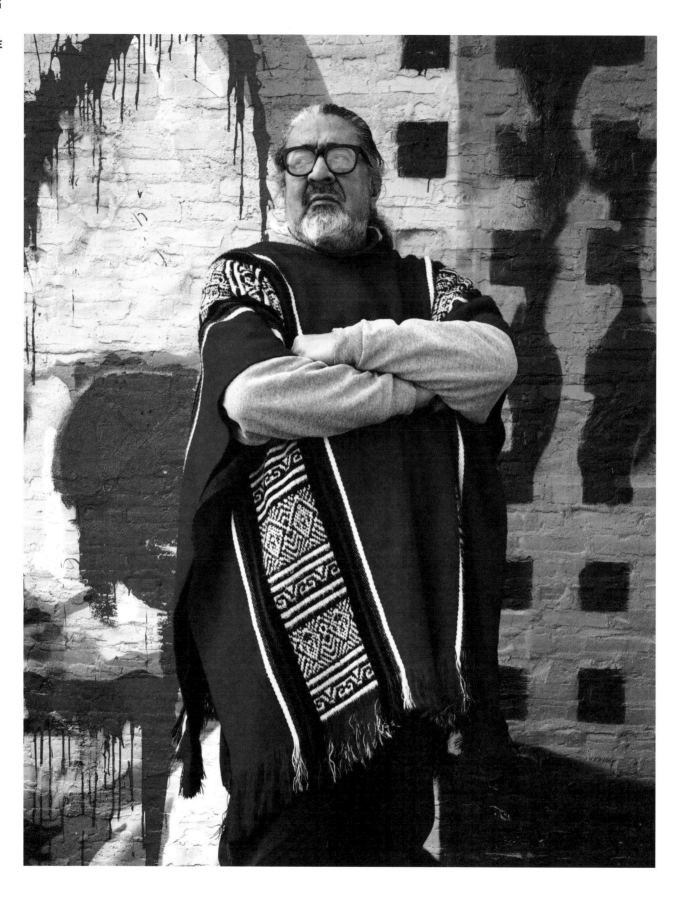

POSTERS

BY

SERGIO MAYORA

**Mommy's at Weeds.
I'll be home by 2 tonight
to feed you.**

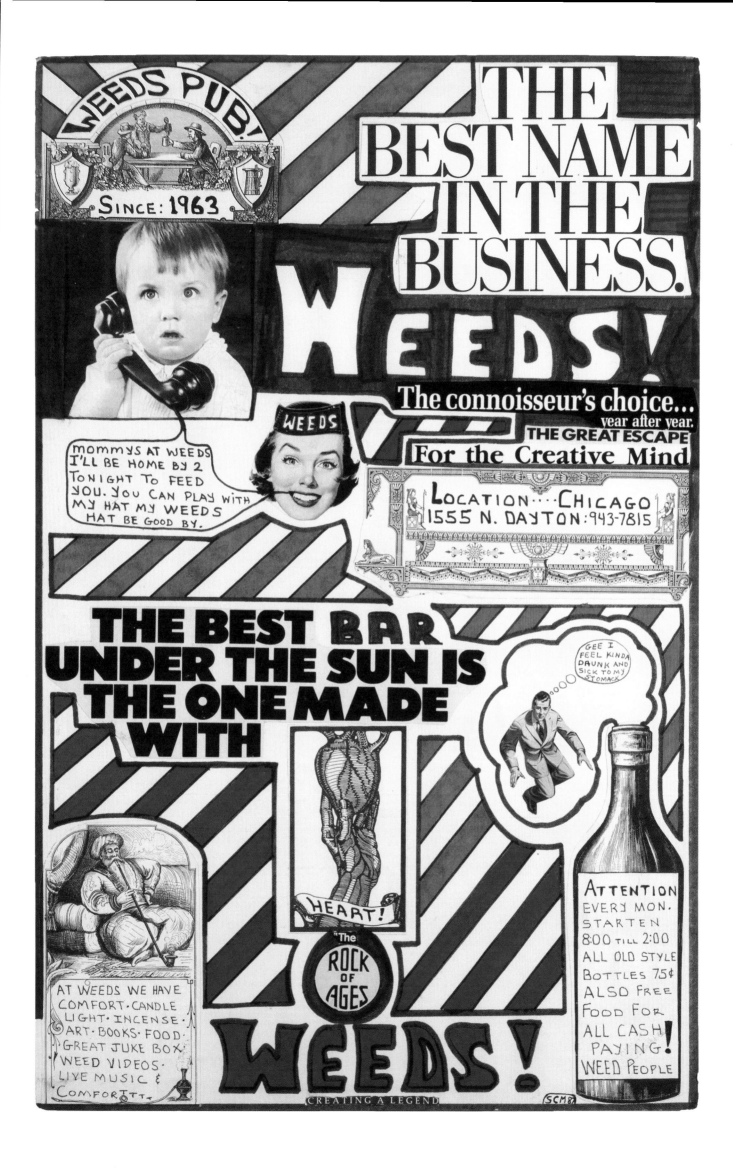

WEEDS

ESTD
SINCE
1963

Mayora for Mayor.
He is not a lawyer.
He's not a T.V. canidate!
He runs a good bar.

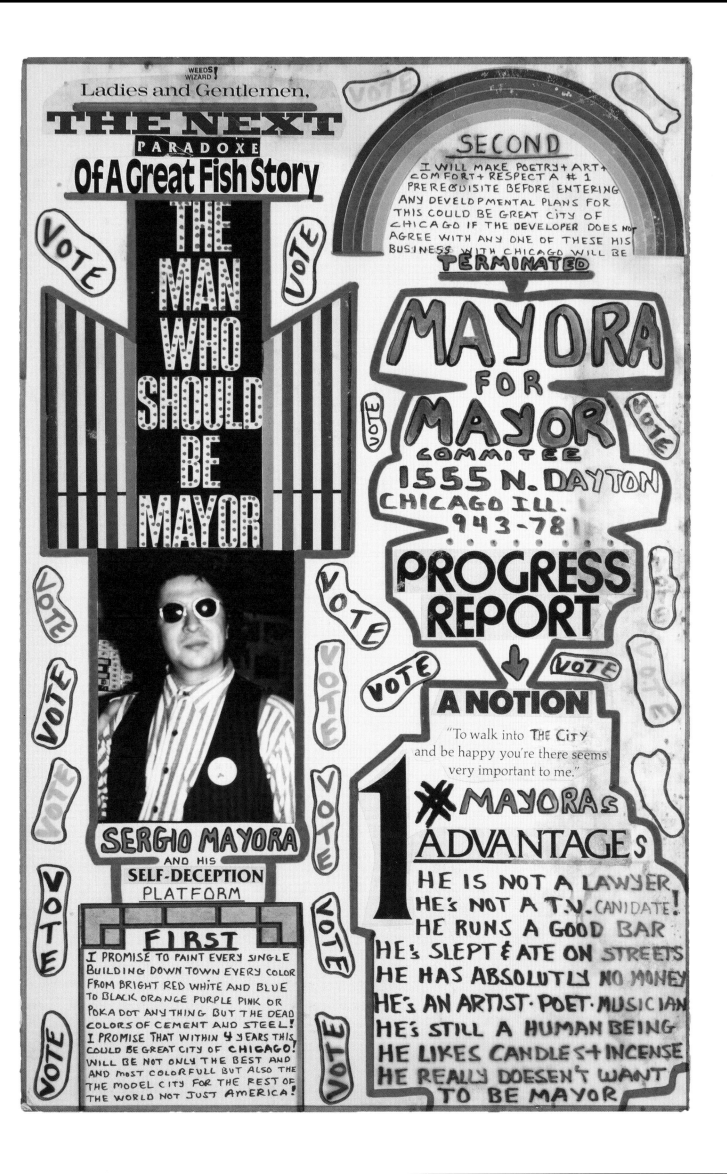

WEEDS

ESTD
SINCE
1963

Weeds is creating a lot of
good legendary Weed people.
That's all you have to know.

WHAT'S WEEDS! DOING BESIDES MAKING GREAT Posters?

WEEDS TAVERN IS NOT JUST ANOTHER FISH IN THE POND

OR A Mad House

LOCATION...
1555 N. DAYTON
CHICAGO ILL.
60611 U.S.A.
OPEN EVERYDAY
943-7815
WERE DIFFERENT

WEEDS BAR FEATUES
INCENSE · CANDLE LIGHT
BOOKS · ART · JUKE BOX
POETRY · WEEDS VIDEOS
JAZZ · ROCK · FOLK · AND
LIVE MUSIC + OPEN
STAGE ON SAT. ONLY
OPEN SINCE · 1963!

WEEDS is creating A lot of good LEGENDRY! WEED·people...

That's all you have to know

WEEDS

ESTD
SINCE
1963

Some people have a
different idea of how
a tavern should look.

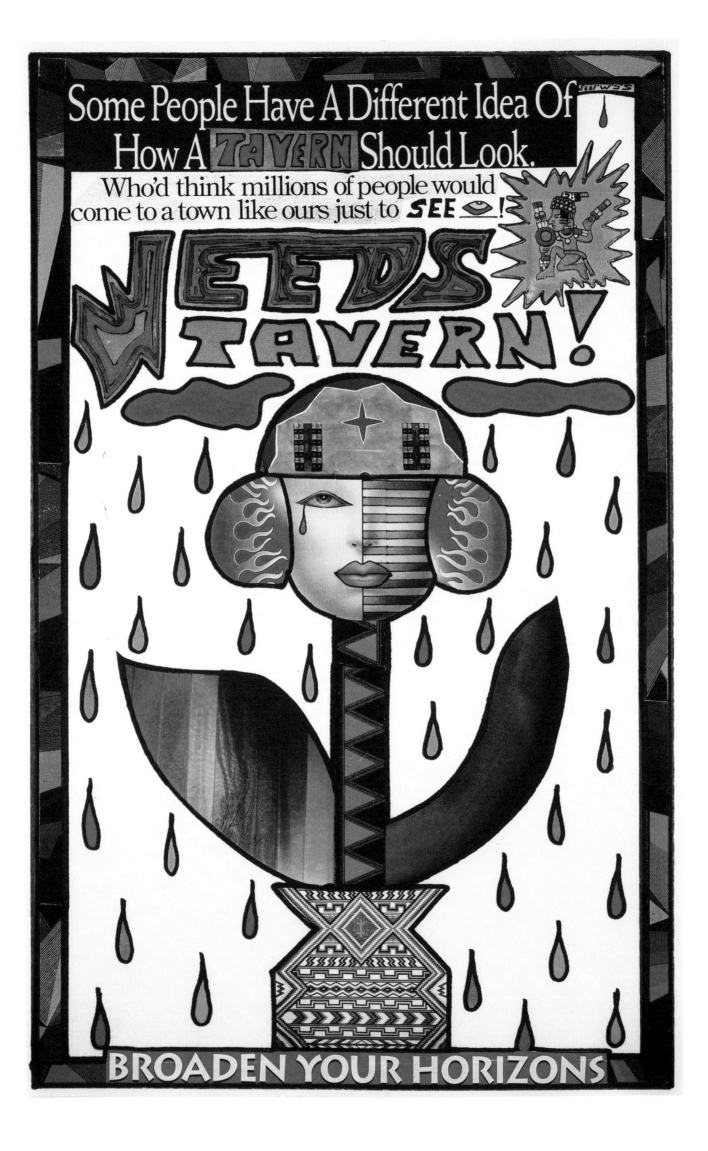

**Weeds will provide a journey
of long enlightenment, with spirits,
candles, incense, music, food, masks,
paint and forever bonds.**

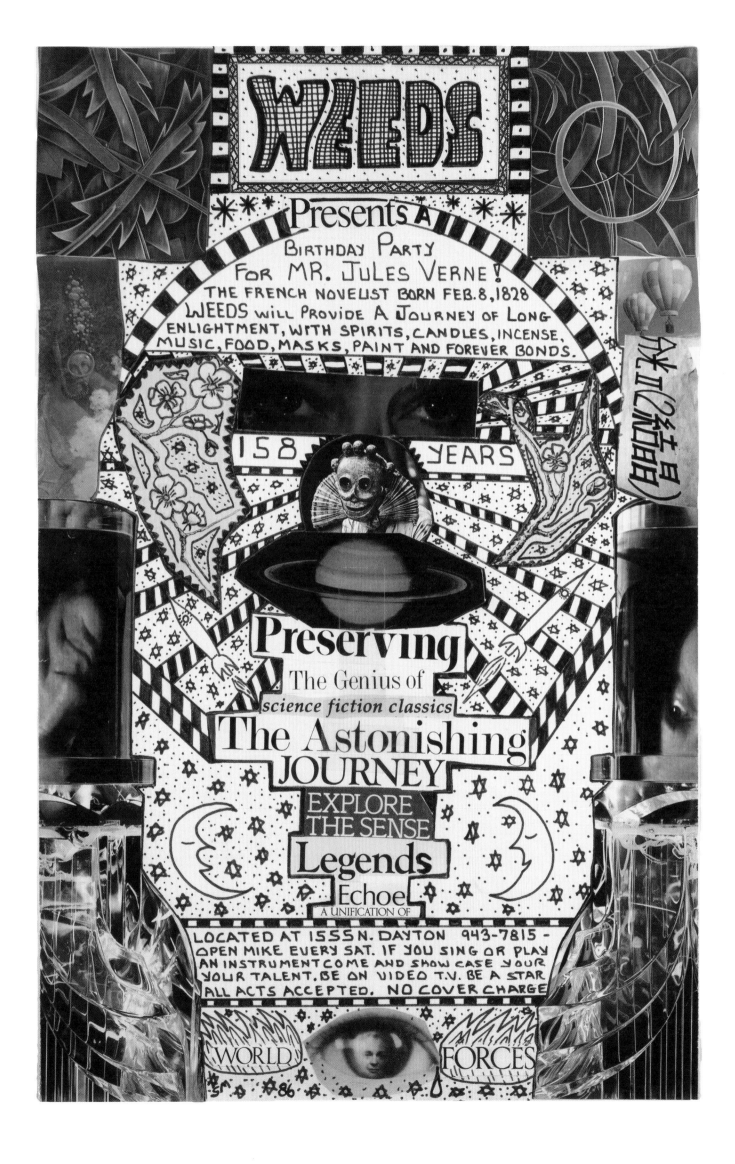

WEEDS

ESTD
SINCE
1963

Come learn. Come touch.
The modern weapon
against boredom.

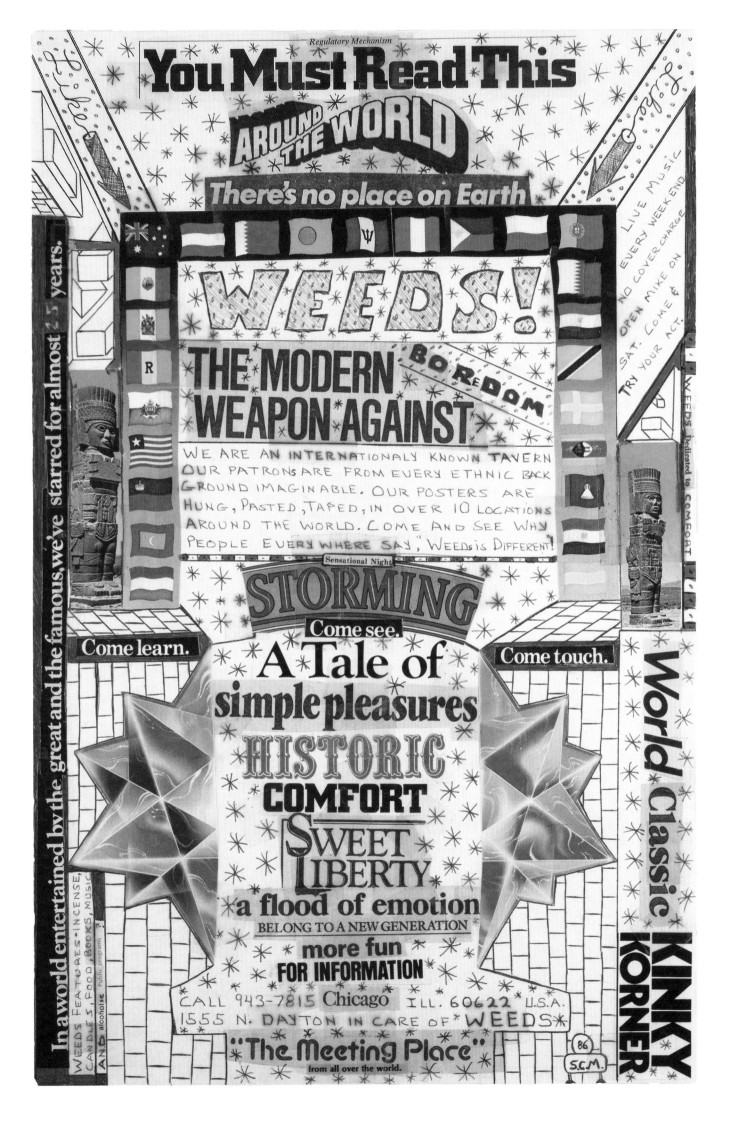

**If Weed people could say
what's on our minds, we'd be
imprisoned, shot, censored.**

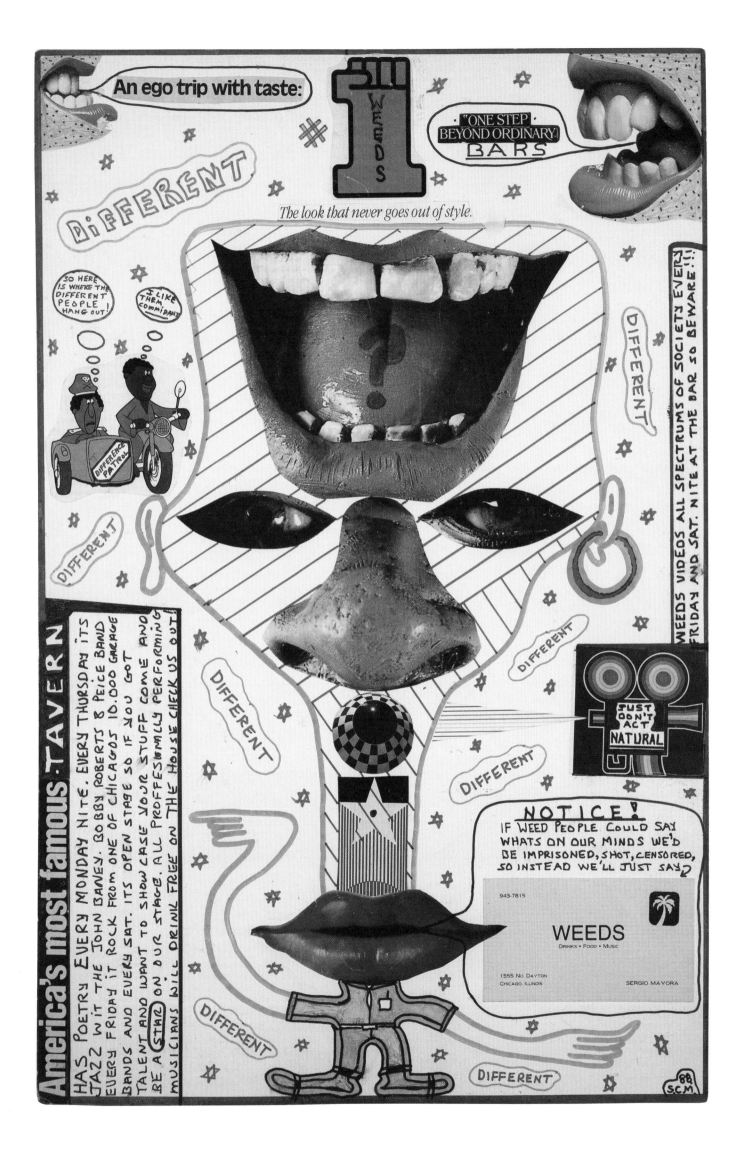

WEEDS

ESTD
SINCE
1963

**Share the experience of the miracle
of life as you view firsthand the
birth of Underwear Day.**

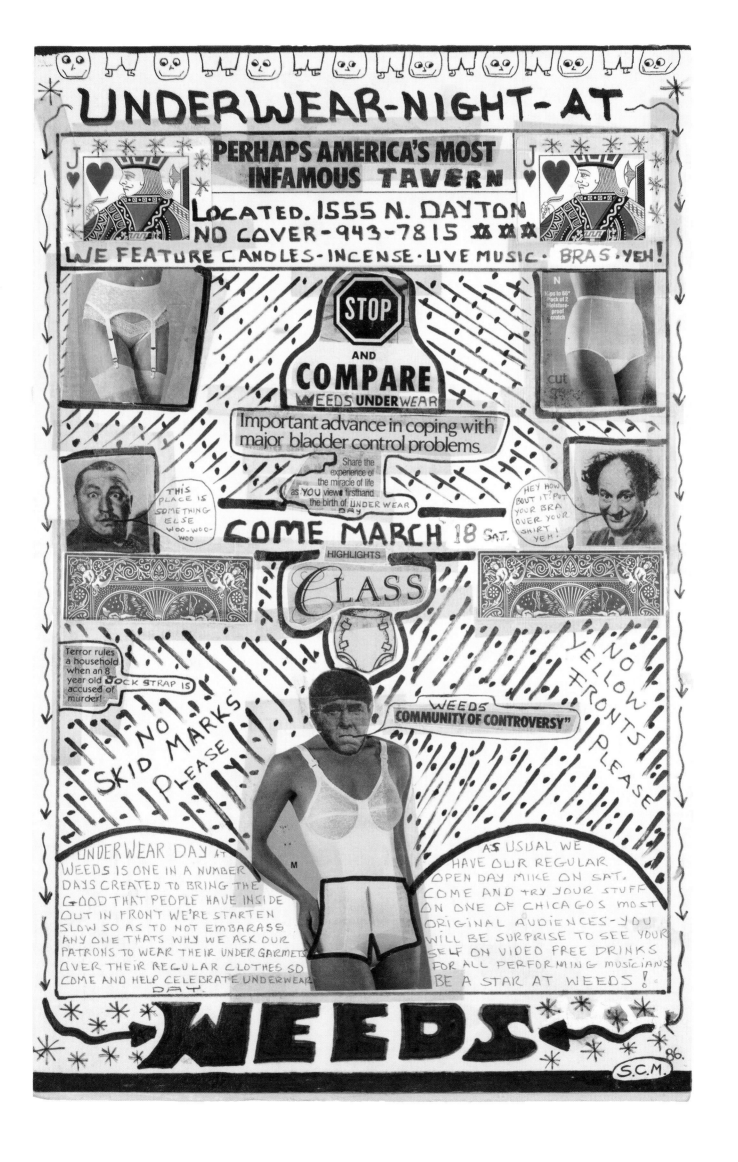

WEEDS

ESTD
SINCE
1963

Weeds people...A new species
(without being rude).

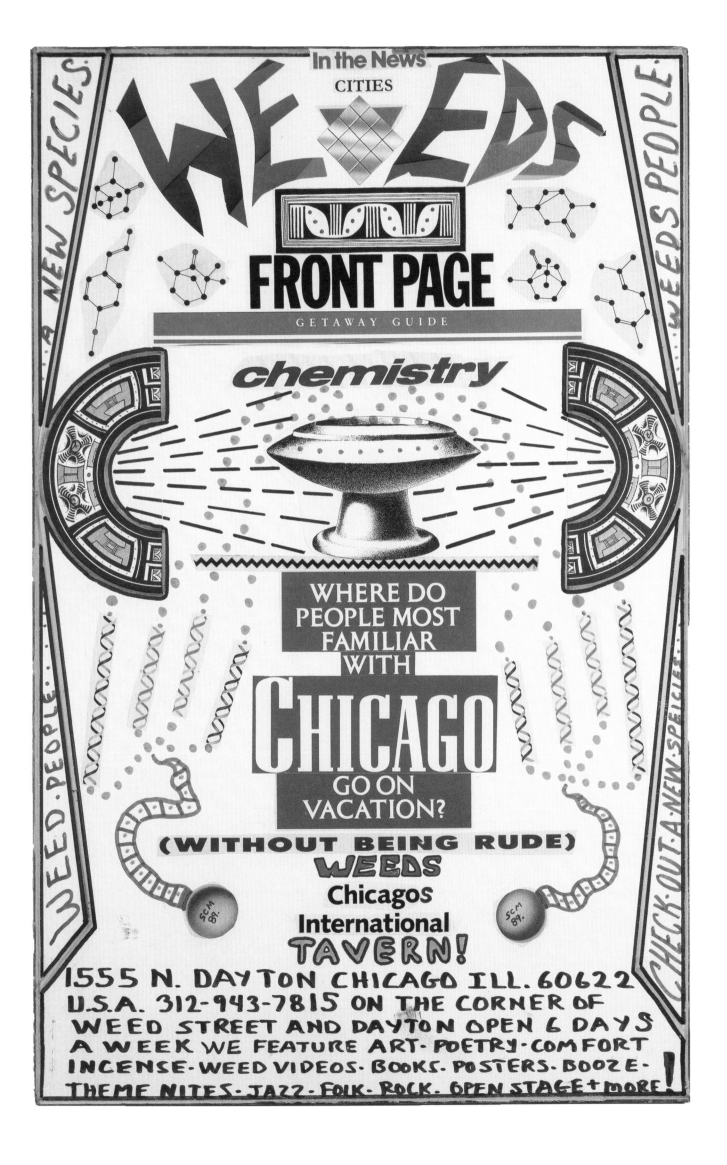

WEEDS

ESTD
SINCE
1963

**America's first natural Mexican
American Puerto Rican Irish Sicilian
German bar in the U.S.A.**

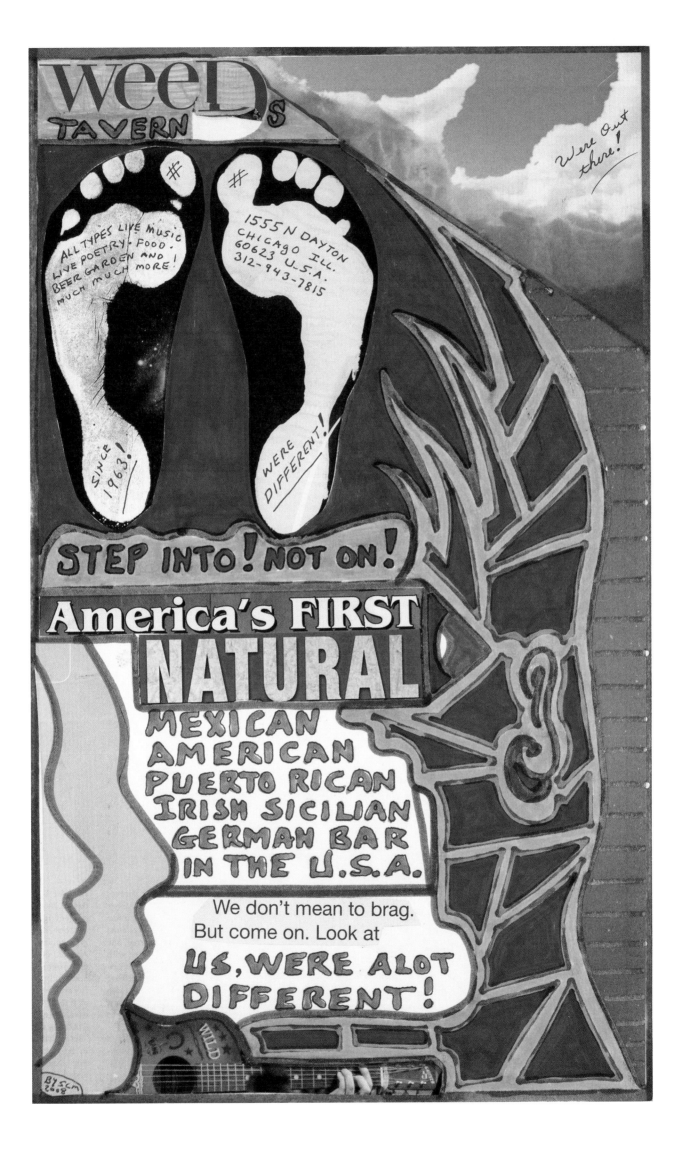

WEEDS

ESTᴰ
SINCE
1963

Annoy
Torment
Bother
Pester
Tease
Harass
Heckle.
Come and celebrate
Punk Night.

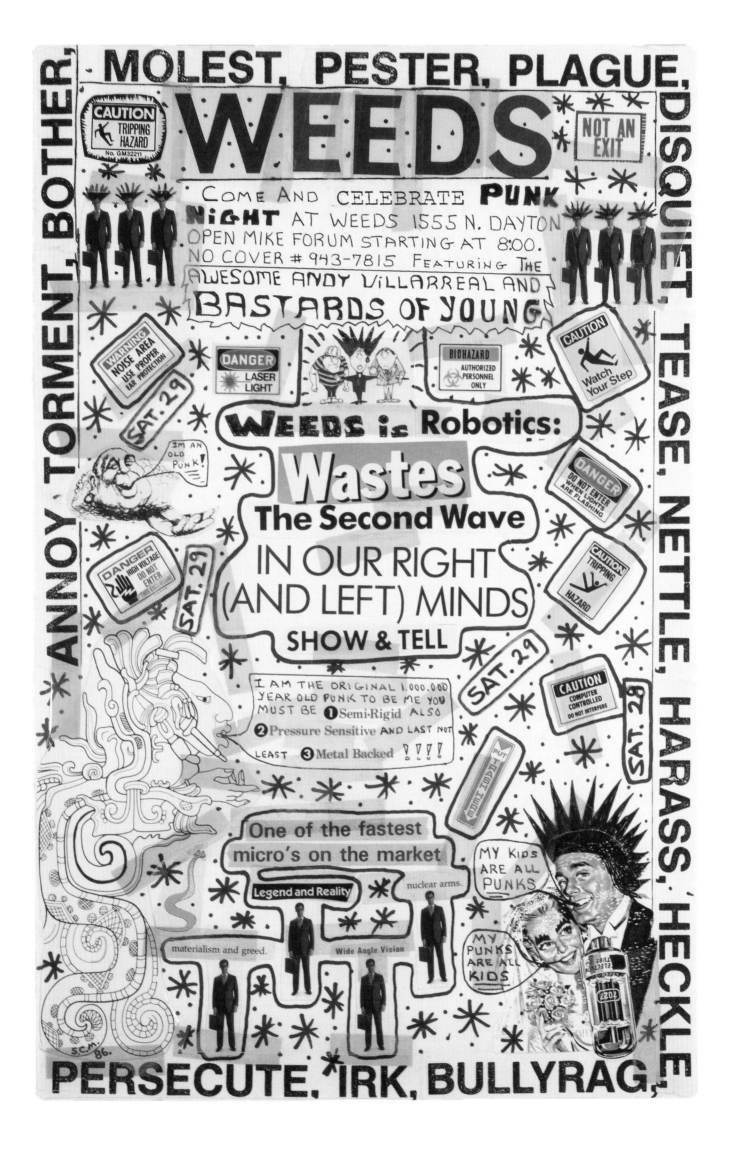

WEEDS

ESTD
SINCE
1963

Every Thursday Mr. Carl Wright
the only internationally recognized
jazz harmonica player in exsistance.
We rest our case.

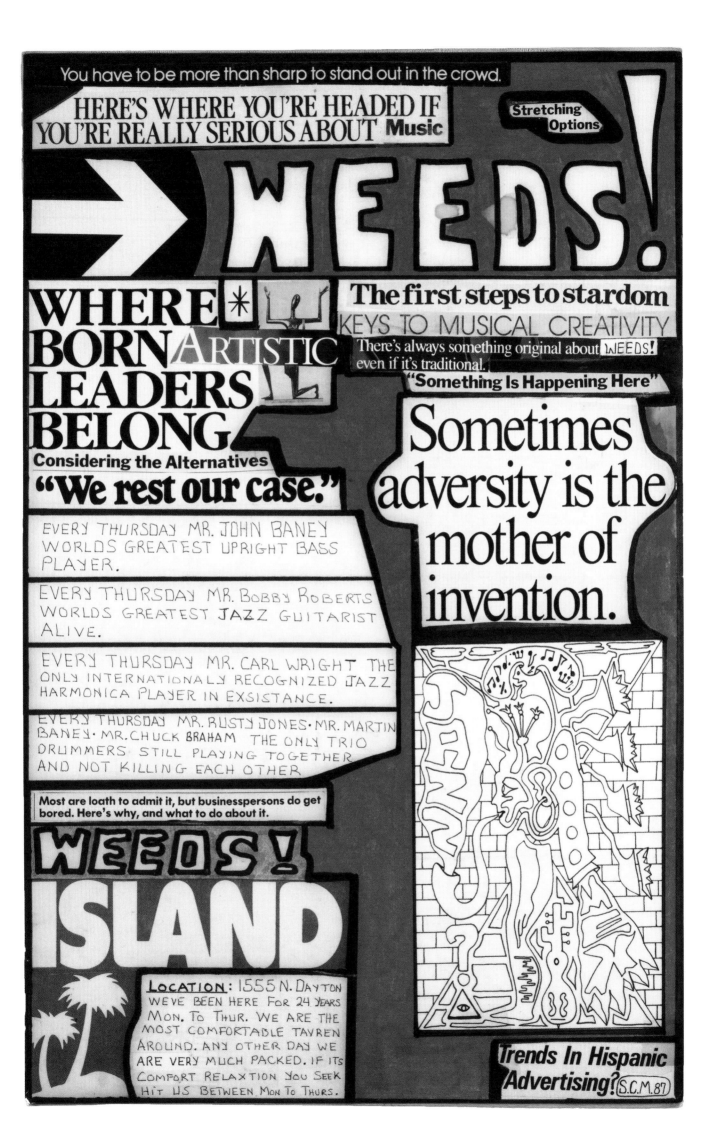

Instead of always taking two weeks
off in Mexico, we built that here—
on a city corner.

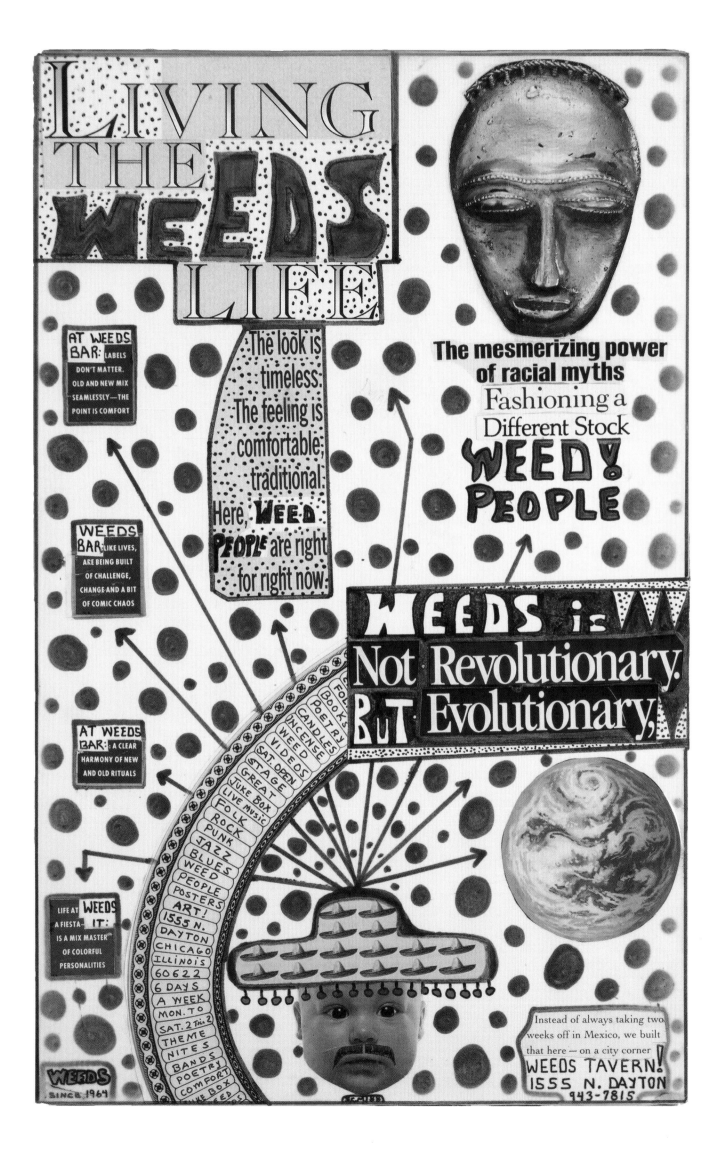

WEEDS

ESTD
SINCE
1963

Easy to be a bar. Hard to be Weeds.
The shape of taverns to come.

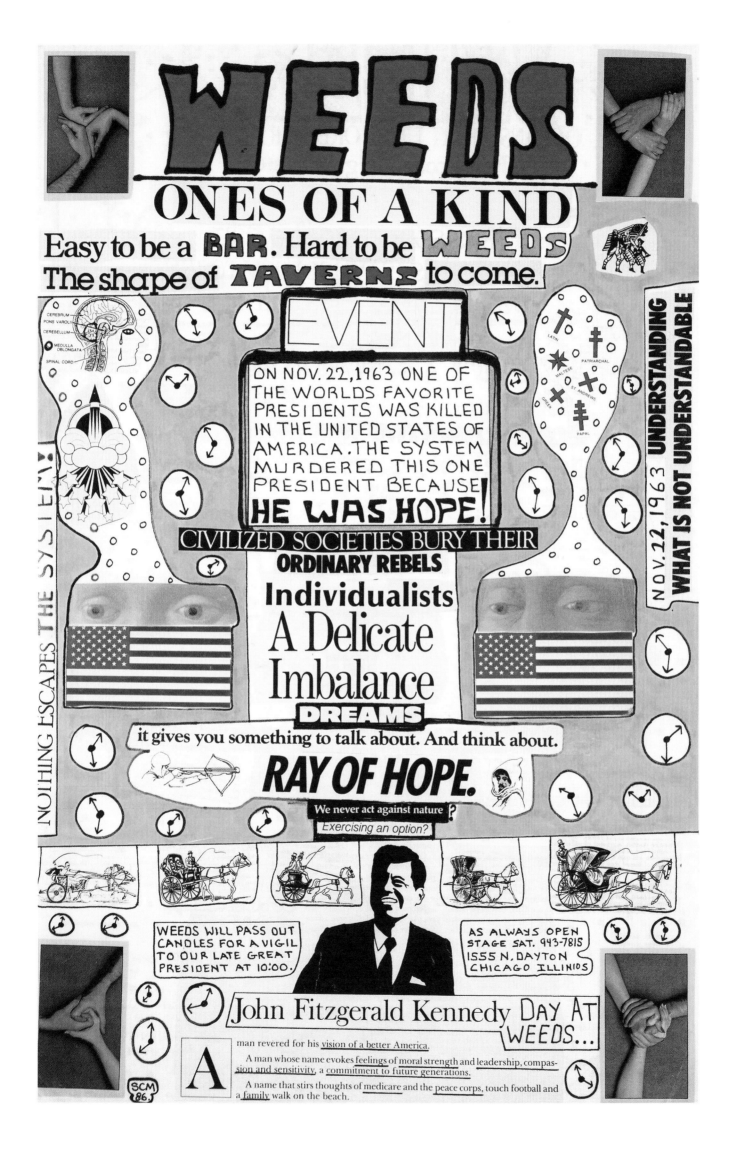

WEEDS

ESTD
SINCE
1963

**The mystique of
provocative atmosphere.
The world is watching.**

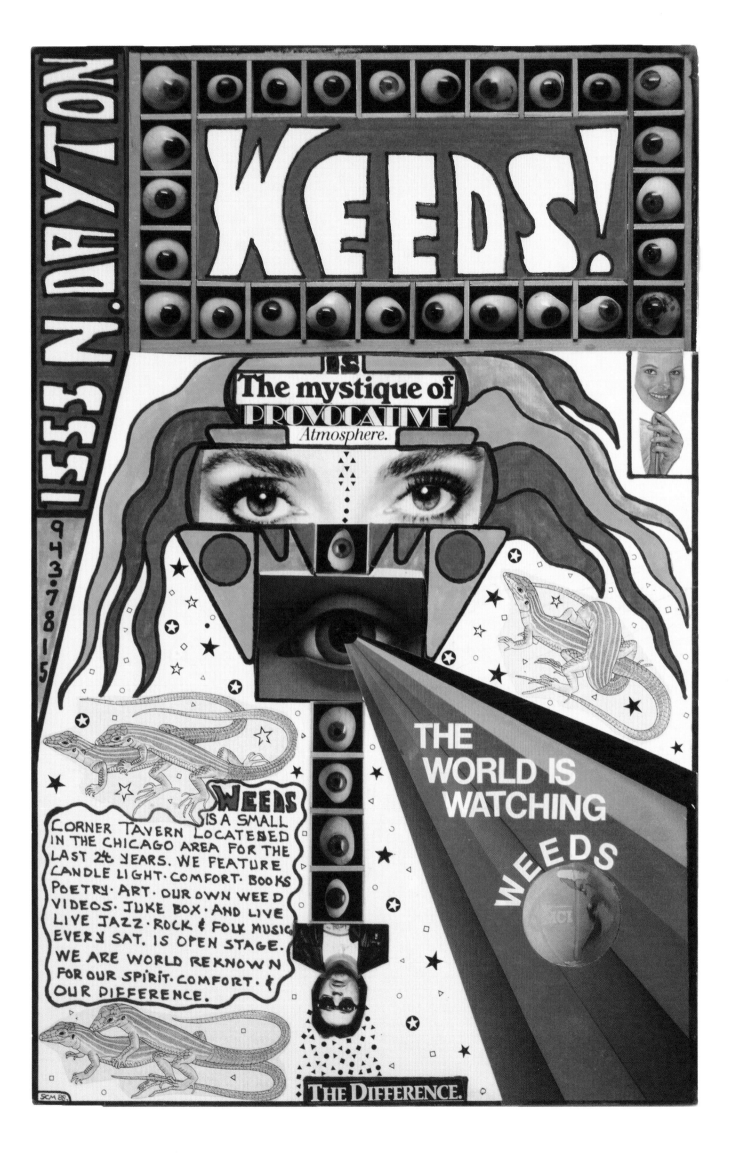

WEEDS
ESTD
SINCE
1963

**The definitive, authoritative,
informative, eye-opening, thorough,
insightful, classic, most quoted,
useful, complete original,
top to bottom.**

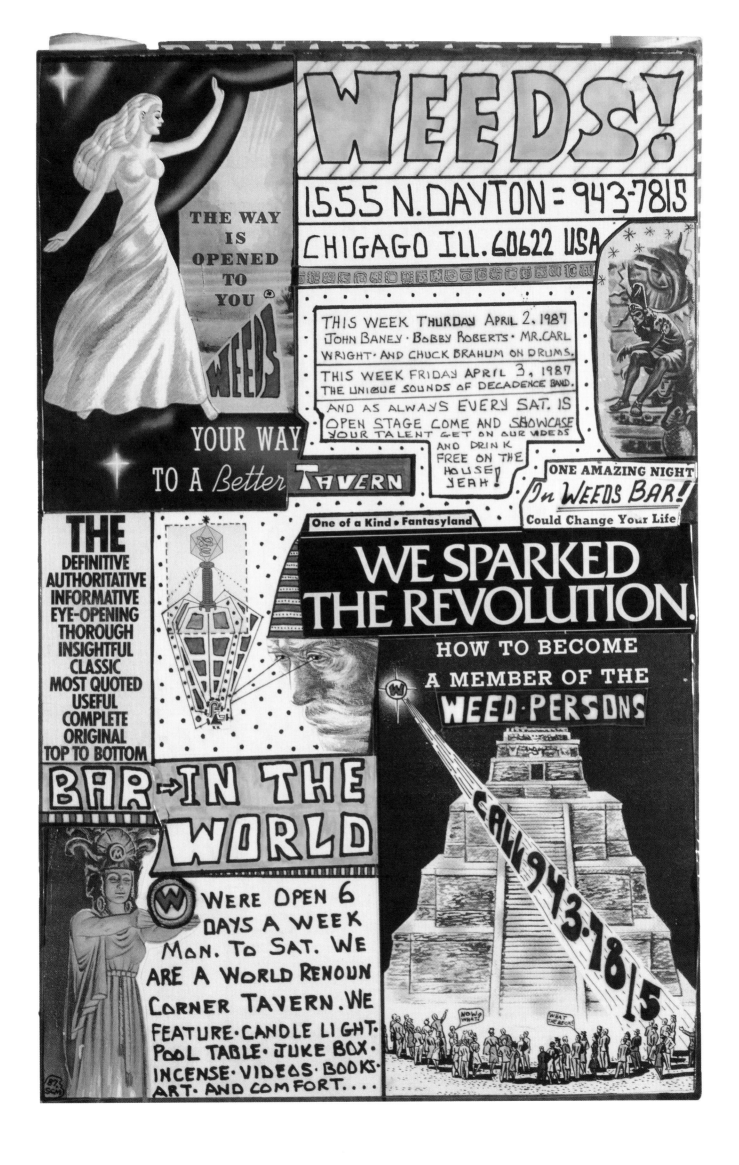

**Not built in a day.
An astronomical small wonder.**

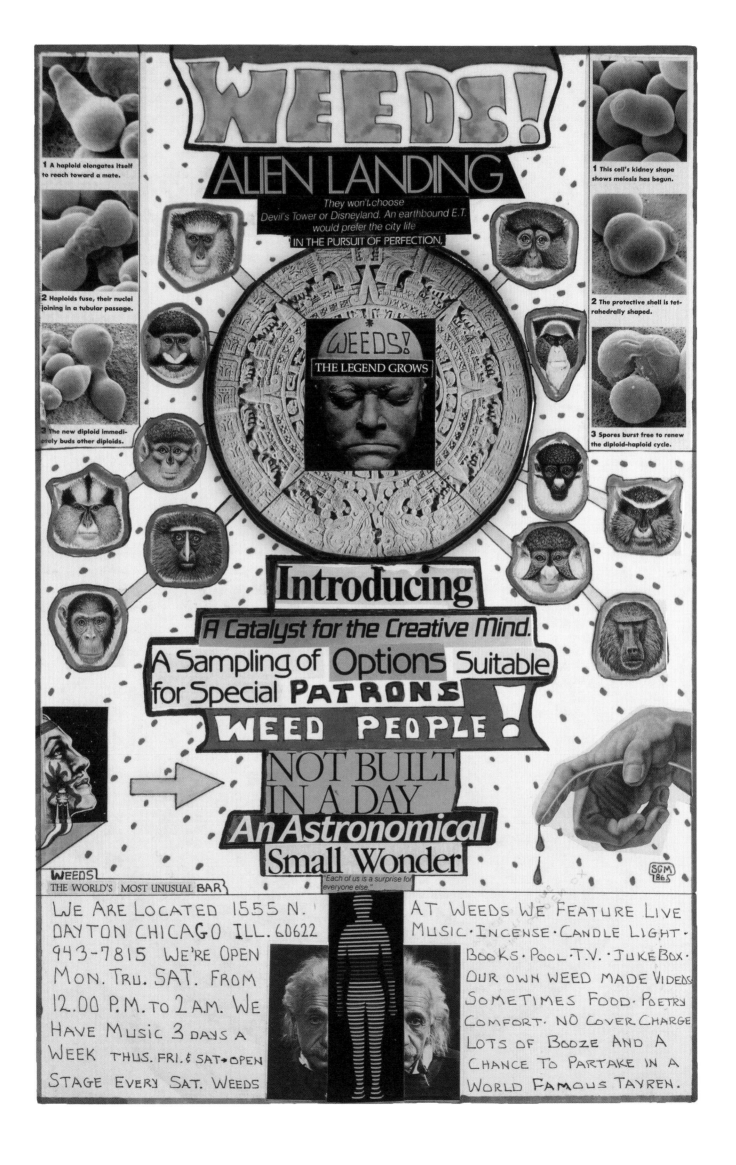

WEEDS
ESTD
SiNCE
1963

Anything the mind can conceive.
Something for everyone.

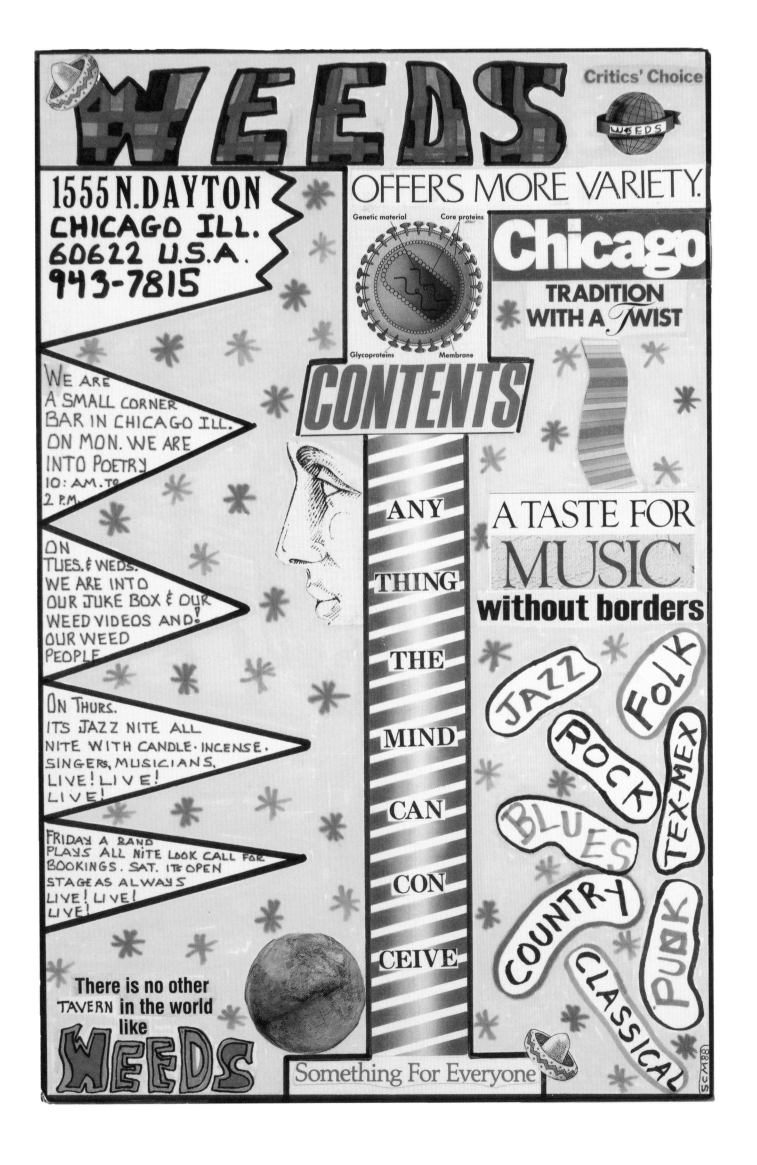

The ultimate recreation for the
restless intellect. The living symbol
of our nation's freedom.

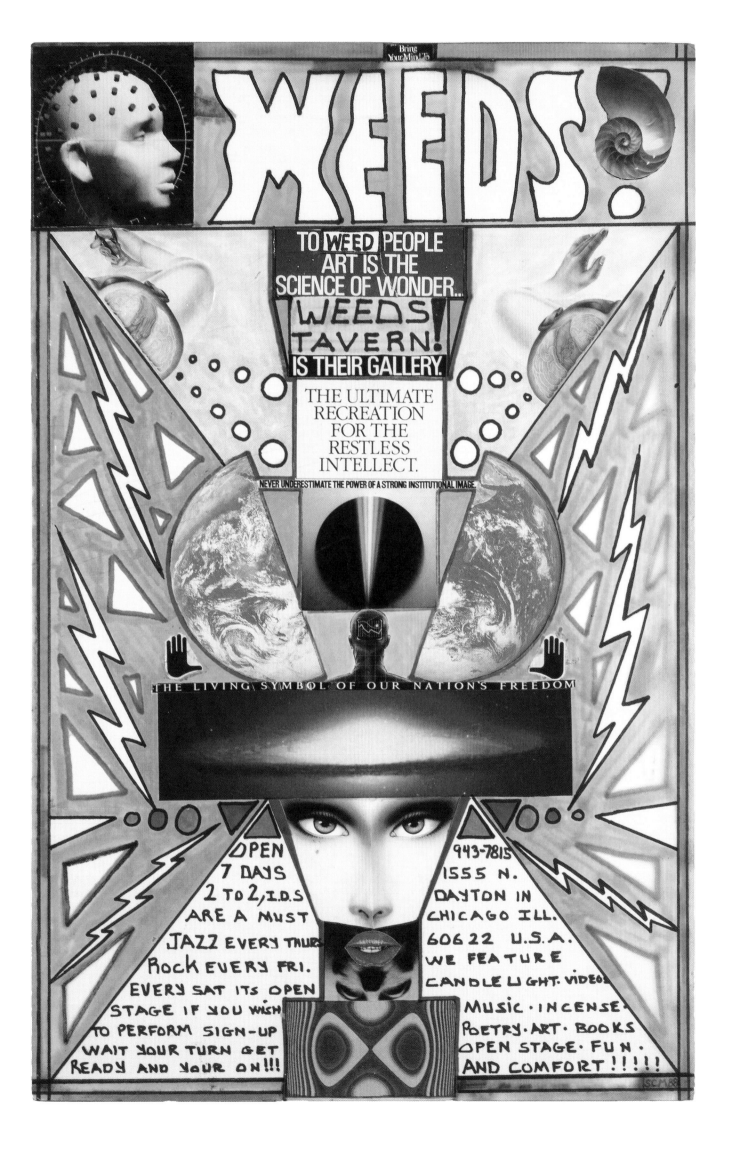

Somewhere along the route of
serving Weeds patrons with comfort
we discovered a vision of world
unity which forever changed the
destinies of Western taverns
all over the world!

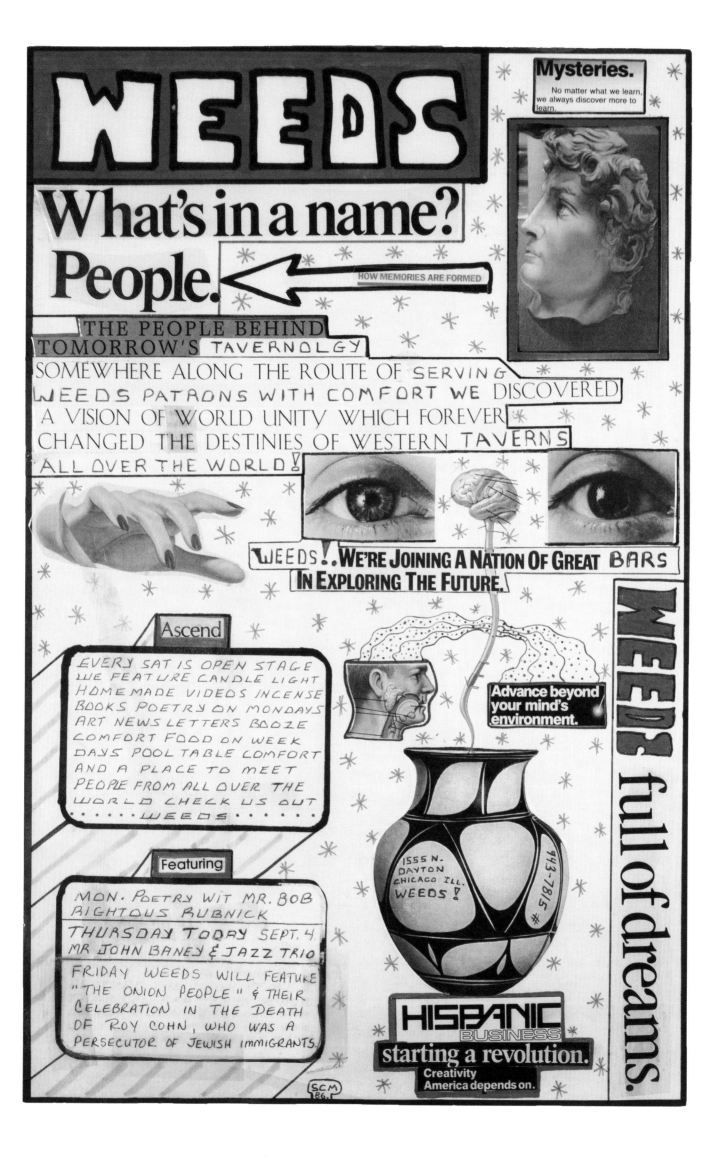

WEEDS

ESTD
SINCE
1963

A bar should not have plays and poetry and books and a bunch of Weed type people!

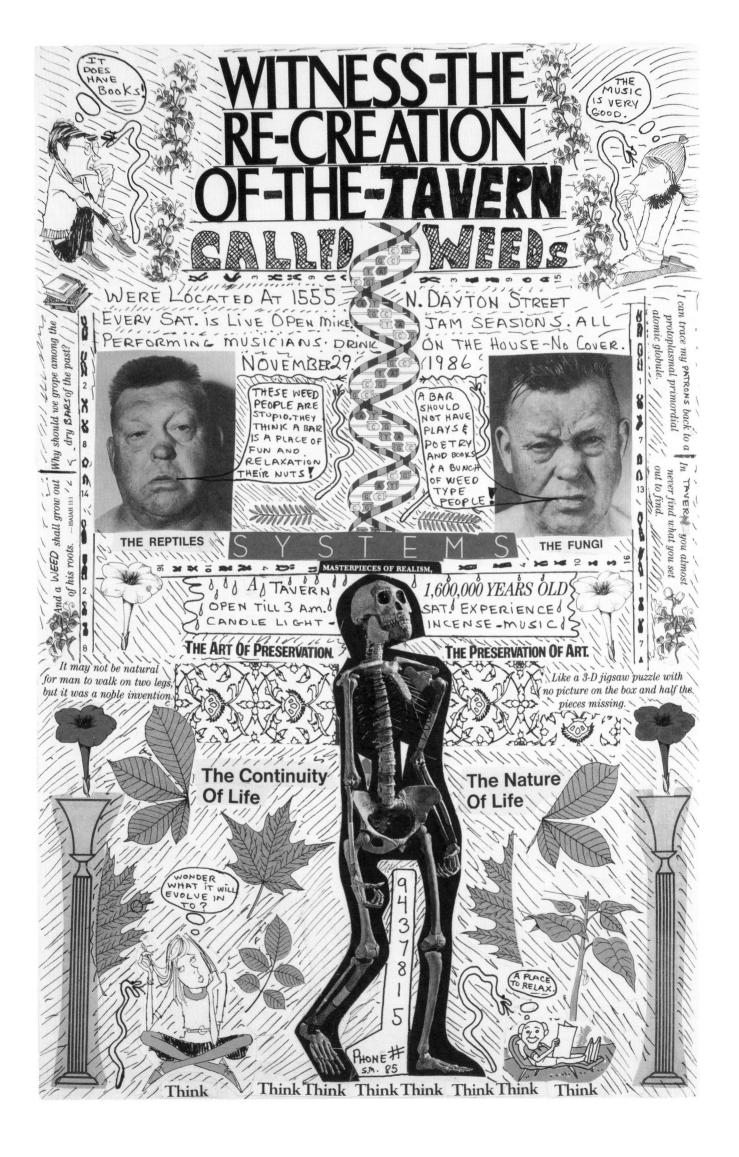

WEEDS

ESTD
SINCE
1963

Solutions for the 90s.
Welcome to the next generation.

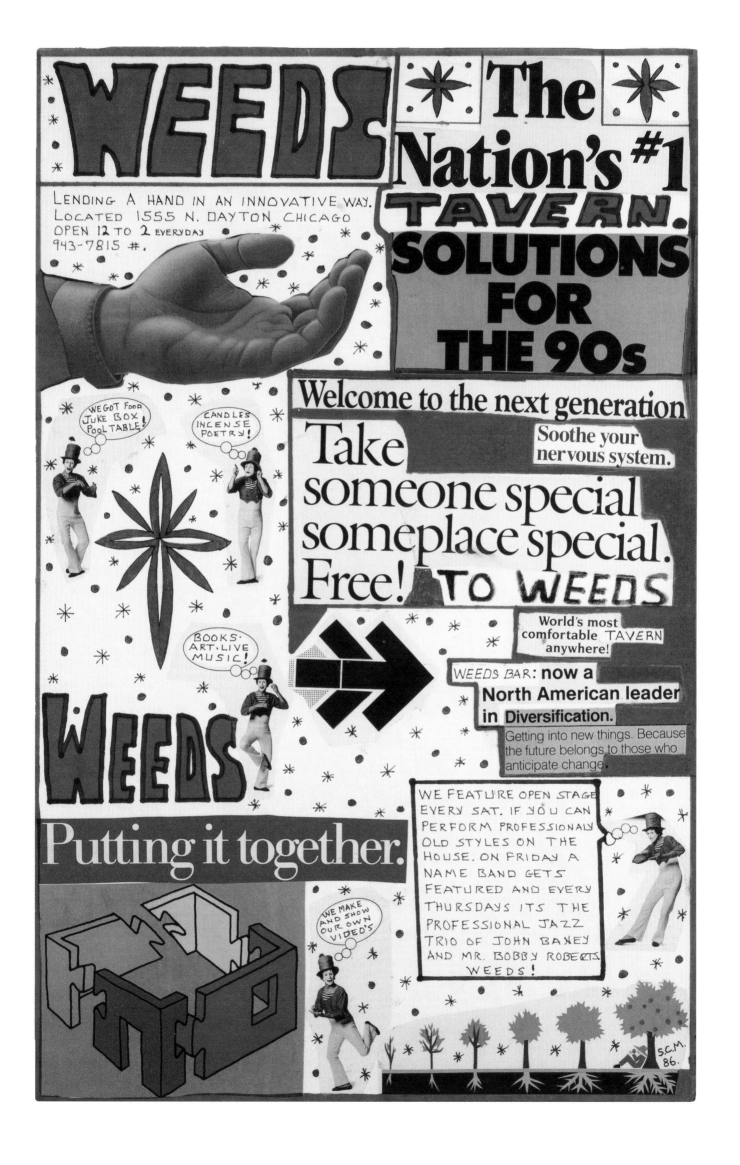

We are your every day normal
corner tavern. Come in and
enjoy the candlelight, the
incense and the magic.

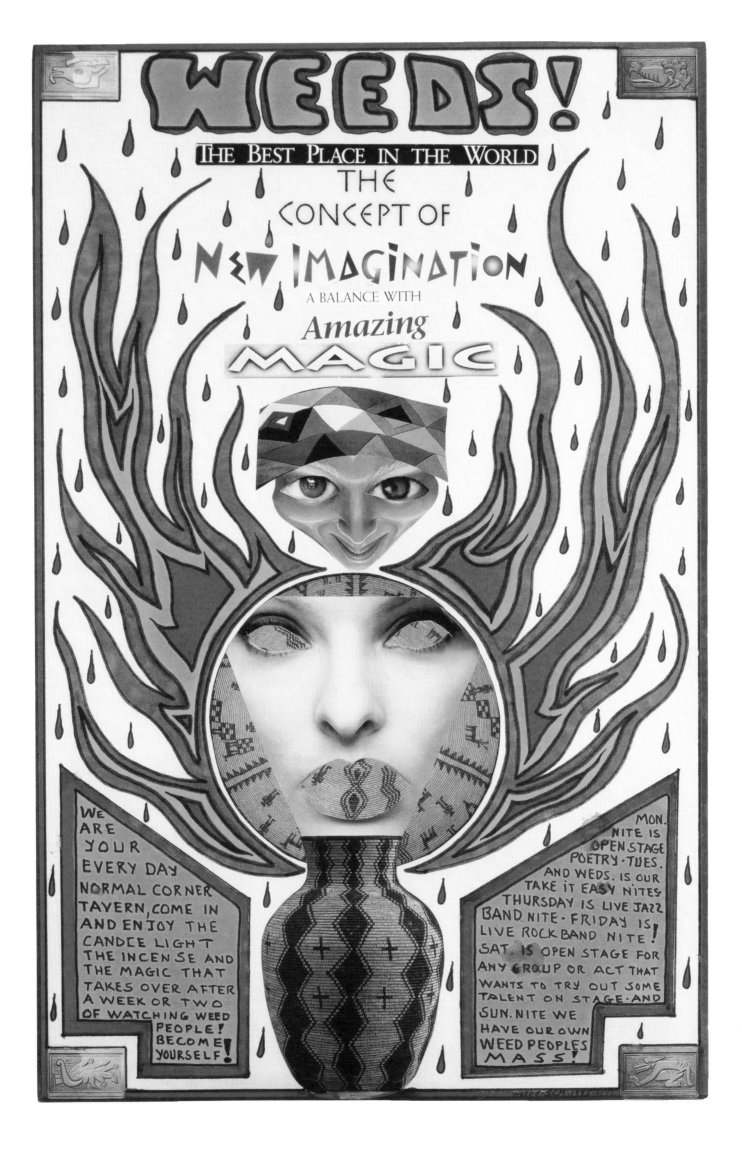

At Weeds we will get right into
the very soul of your brain and
destroy blow up that evil corporate
mentality before you can say L.S.D.

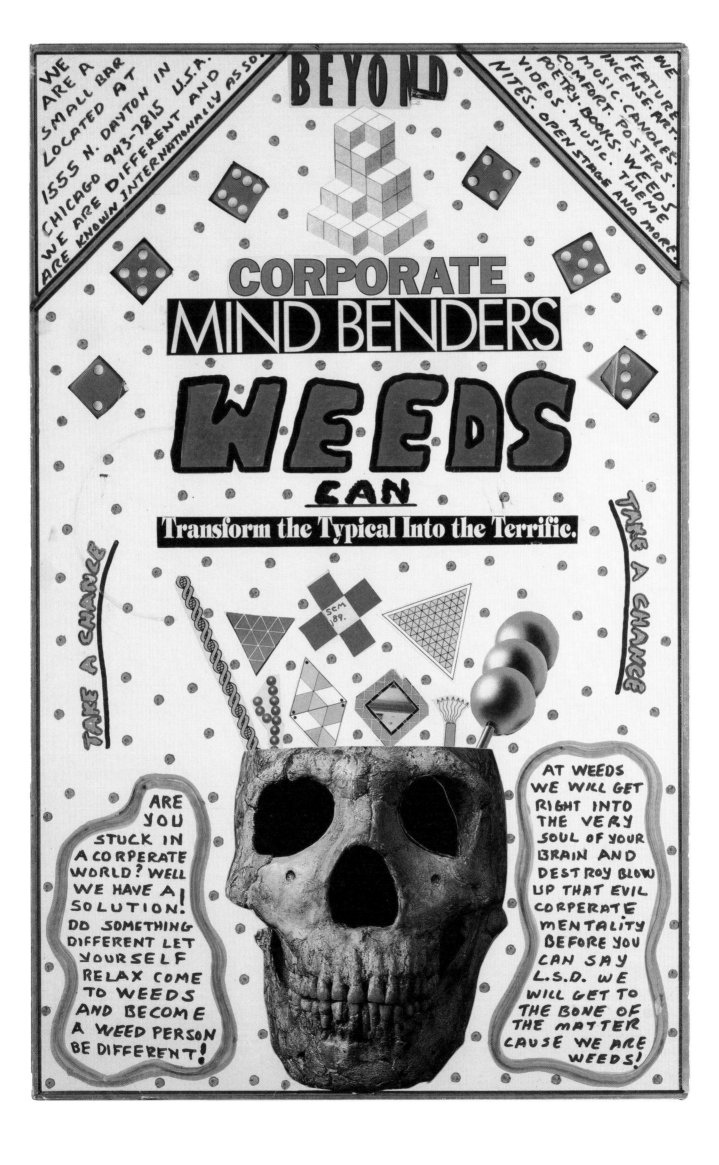

WEEDS

ESTD
SINCE
1963

Relax. Get Comfortable.
Buy a shot of tequila.
Buy me one too.

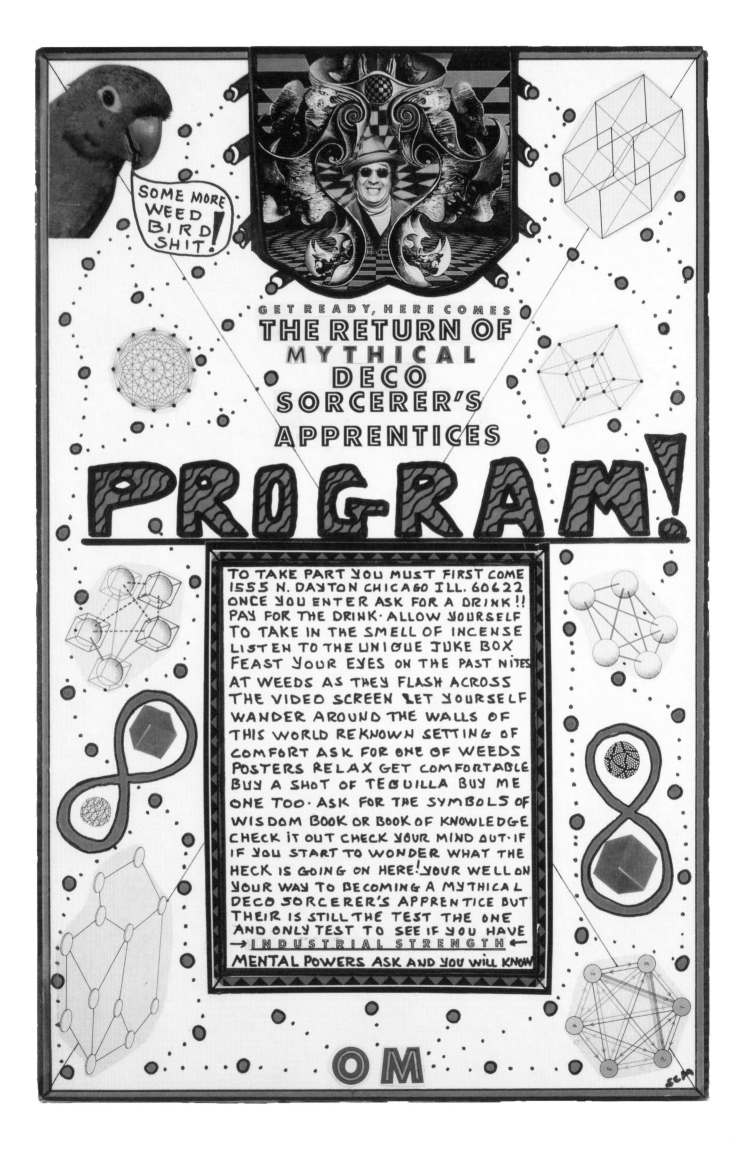

**Sophisticated. Refined.
The most civilized way
to leave civilization.**

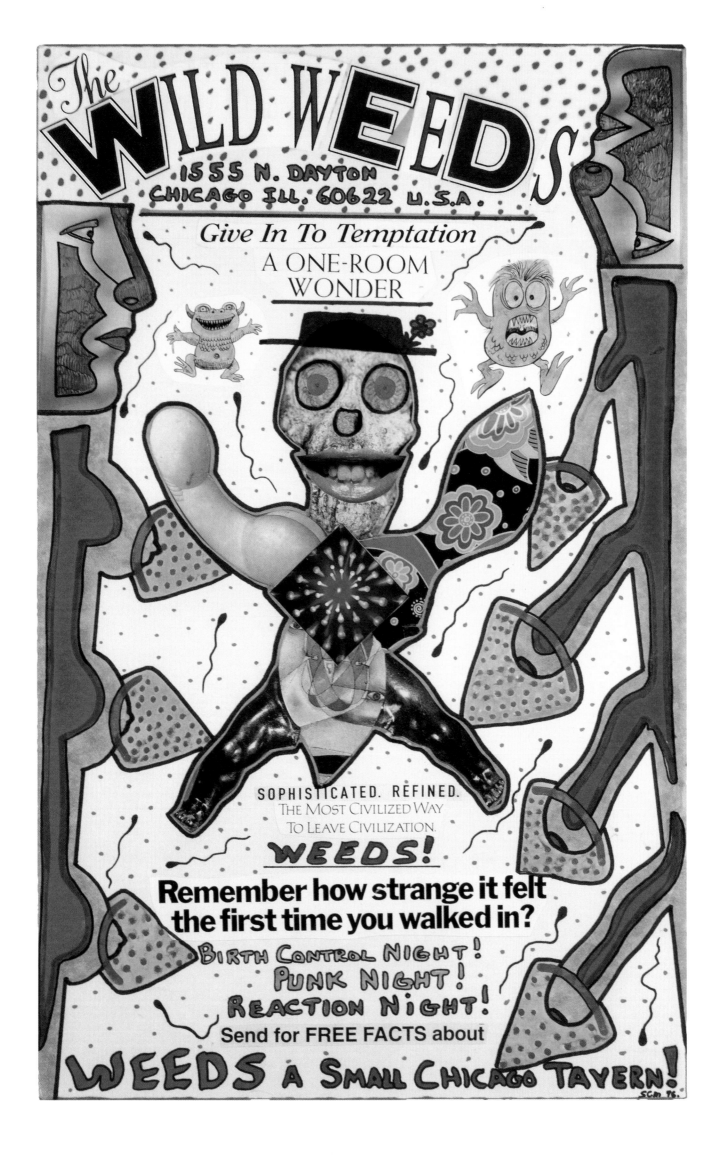

**Weeds is tic-tic-ticked off!
Something isn't right about
this 600% property tax hike.**

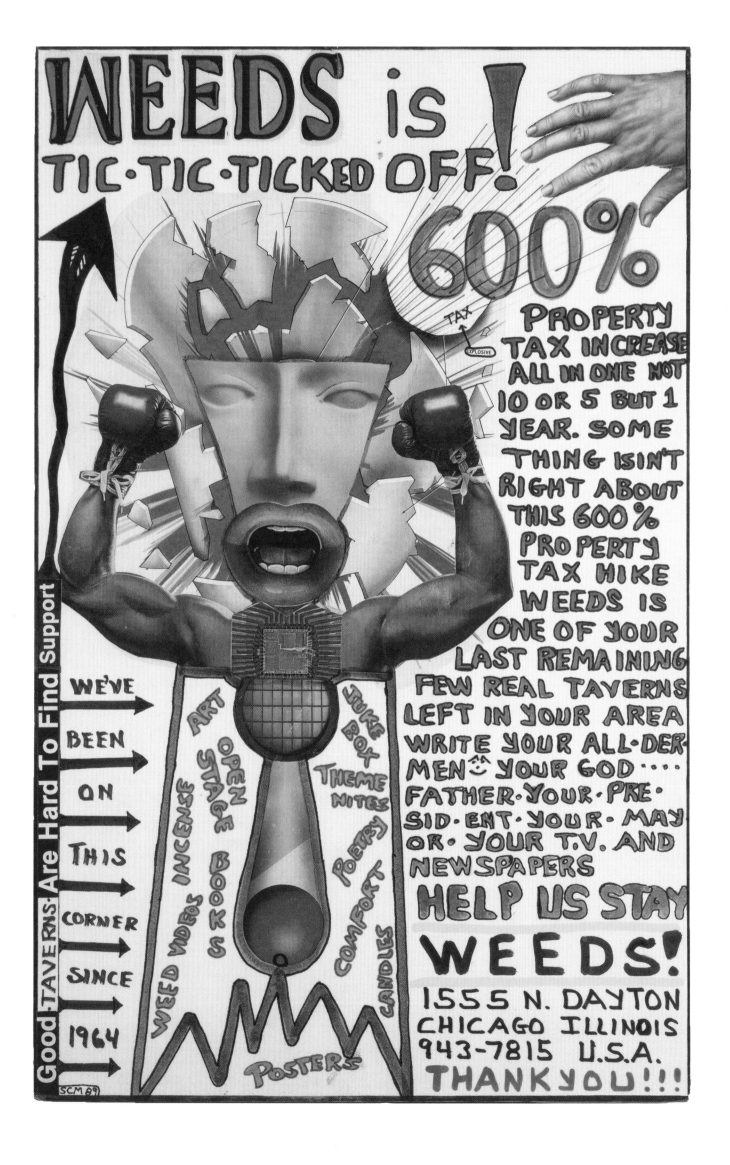

It would be comparatively
easy, quick and cheap to send
human beings to Weeds!

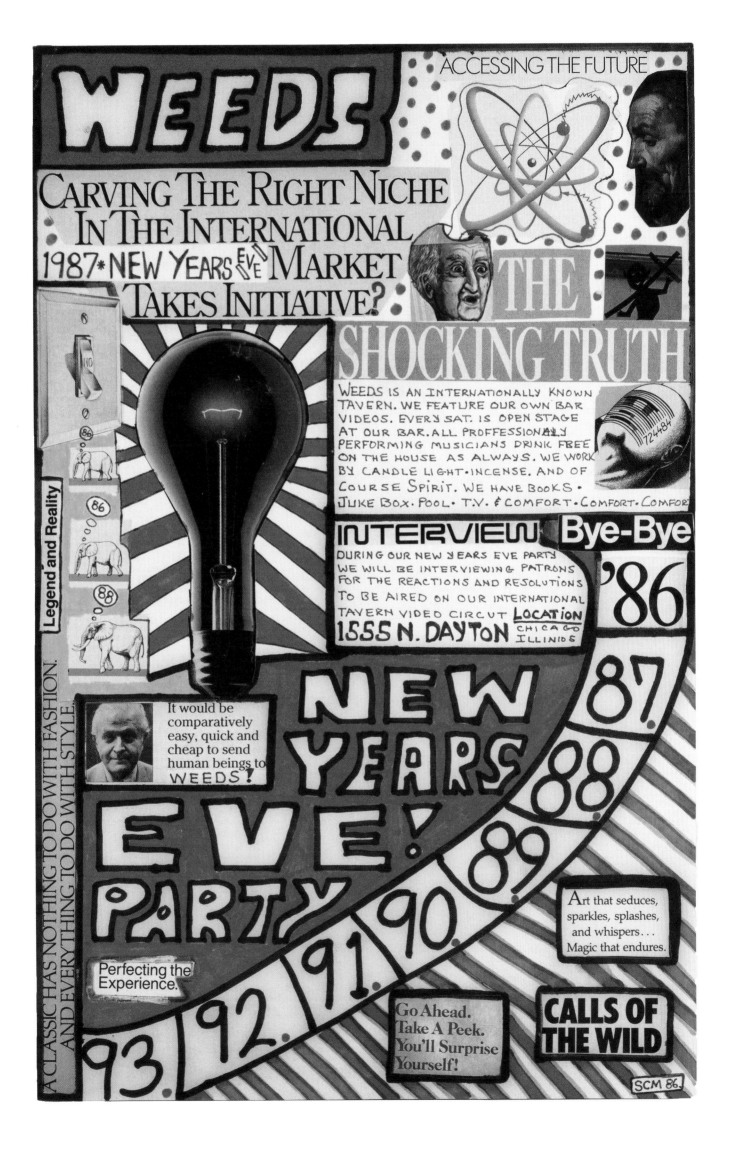

The artful playground for the seen
and noted mind openers.

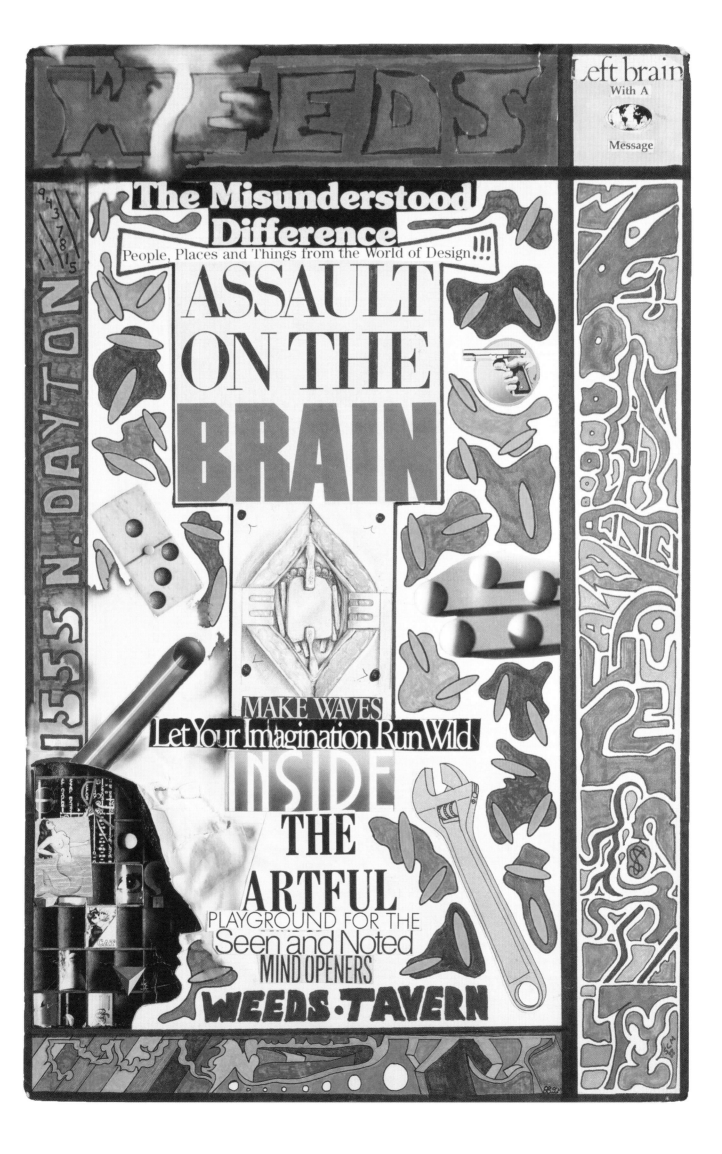

**Innovation: featuring options
and other exotica.**

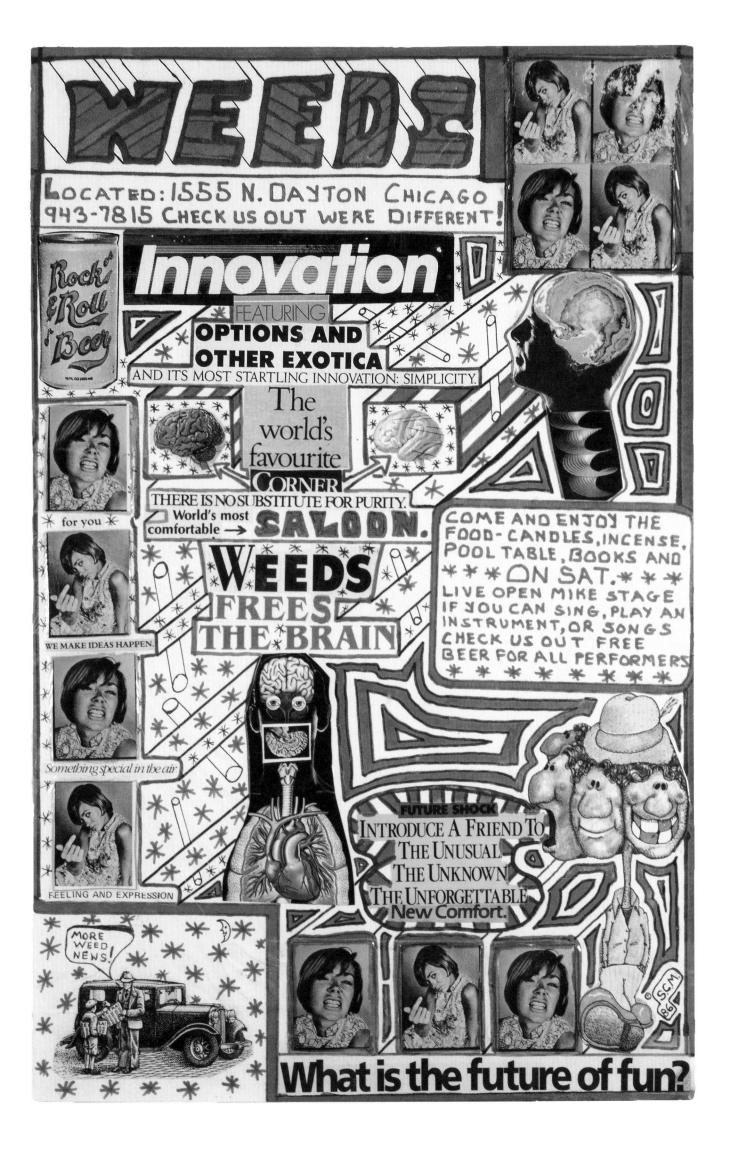

WEEDS

ESTD
SINCE
1963

Weeds presents:
The Fascinating World of Bird
Brains and their Stupid Shoes.

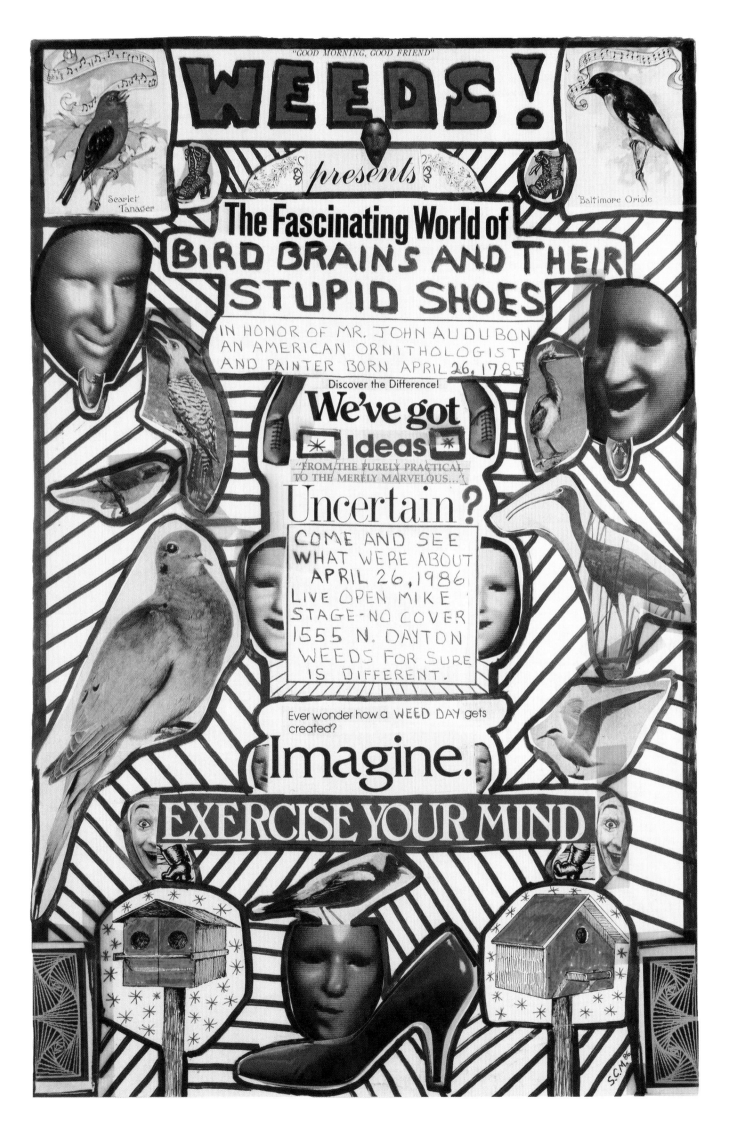

WEEDS

ESTD
SINCE
1963

Uncommon poets are at Weeds!!!
Invite some friends over.
And make waves.

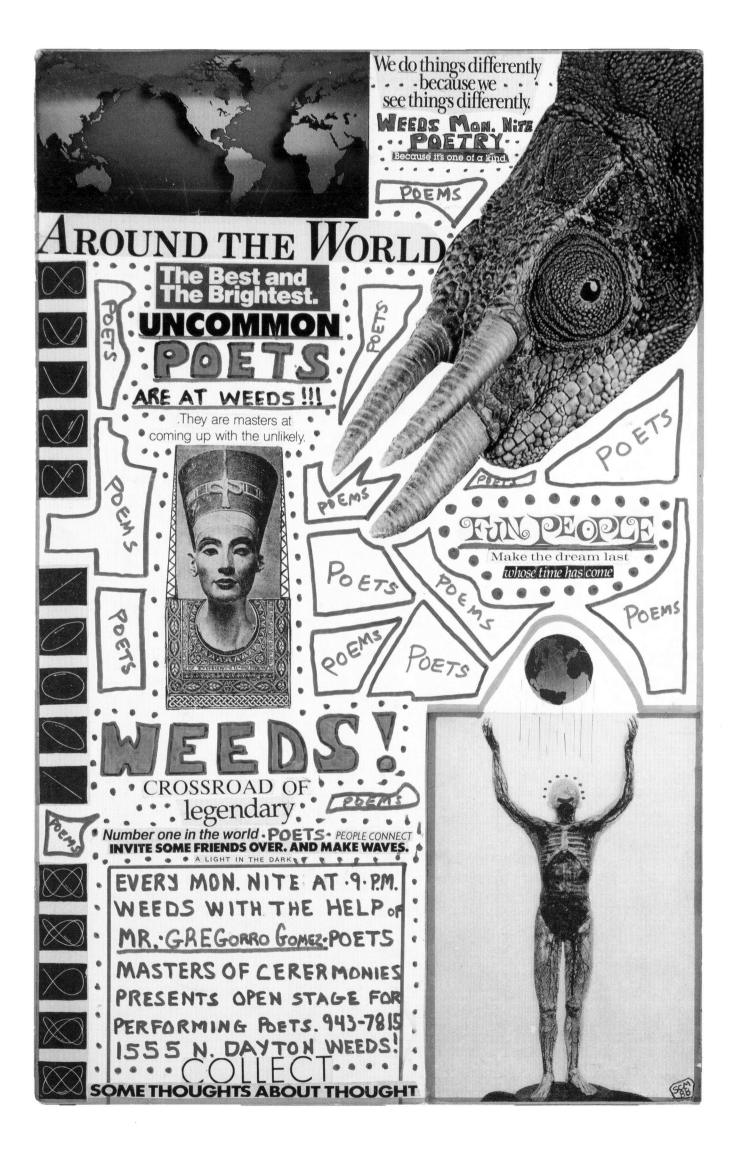

WEEDS

ESTD
SINCE
1963

Are you dummy material?
Join the anti-nincompoop crusade!

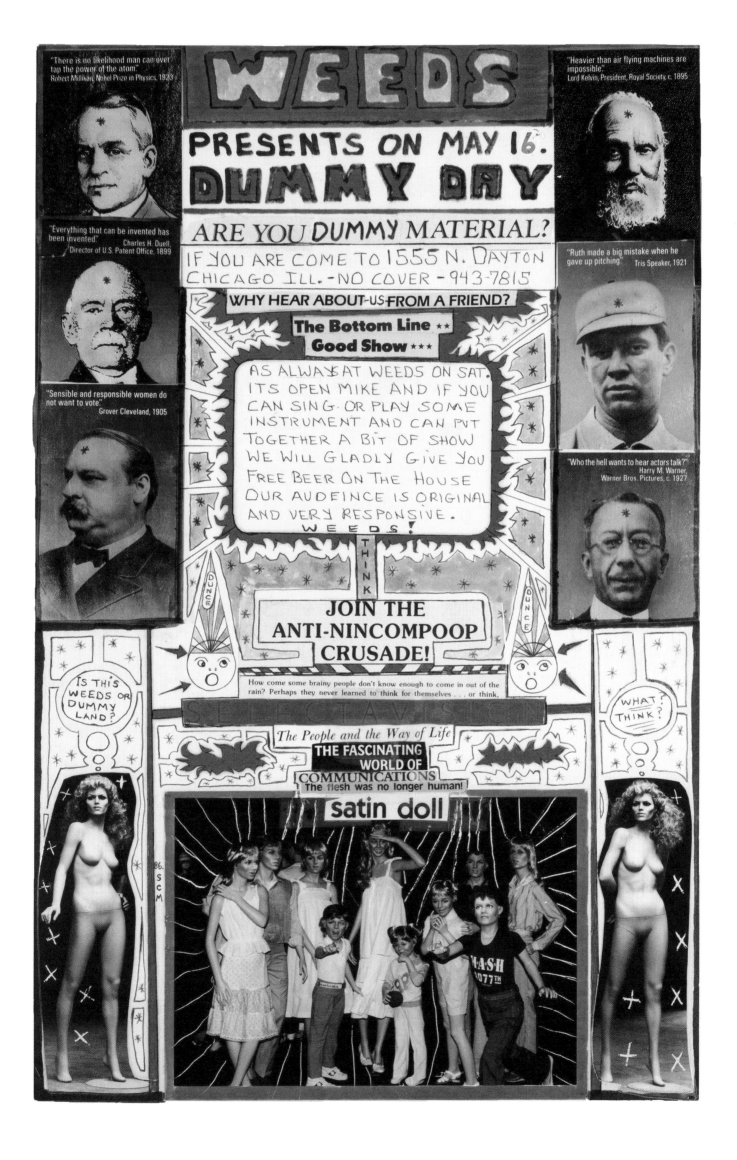

WEEDS

ESTD
SINCE
1963

On the edge of international
entertainment, culture
and history.

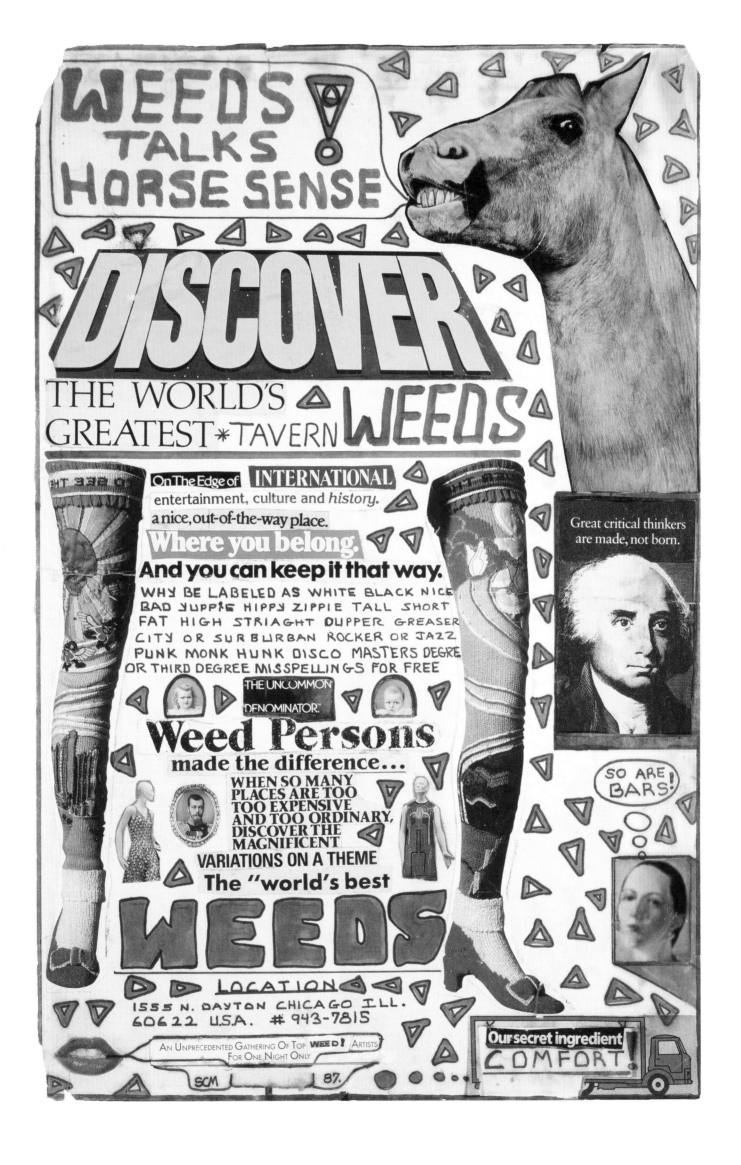

WEEDS

ESTD
SINCE
1963

93 is dead.
Welcome to chaos: 1994.

WEEDS

ESTD
SINCE
1963

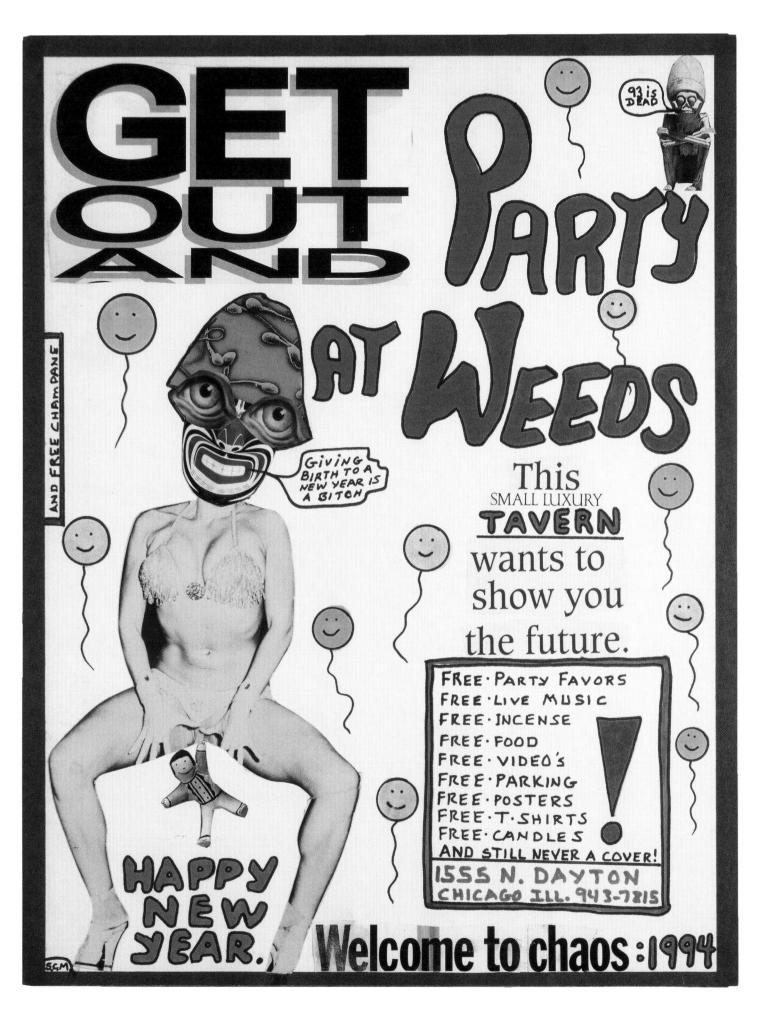

Pollution Control.
Global warming has begun,
and we had better start preparing
for the dramatic changes to come.

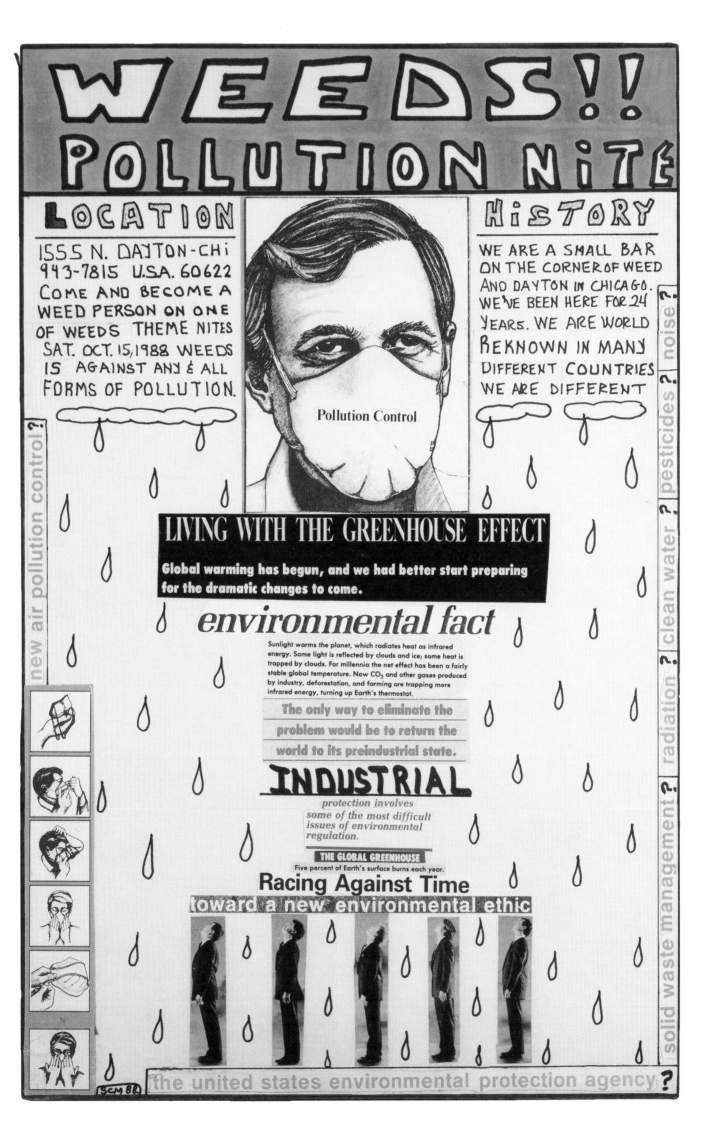

WEEDS

ESTD
SINCE
1963

The problem isn't how little
we care. The problem is how
little we do about it.

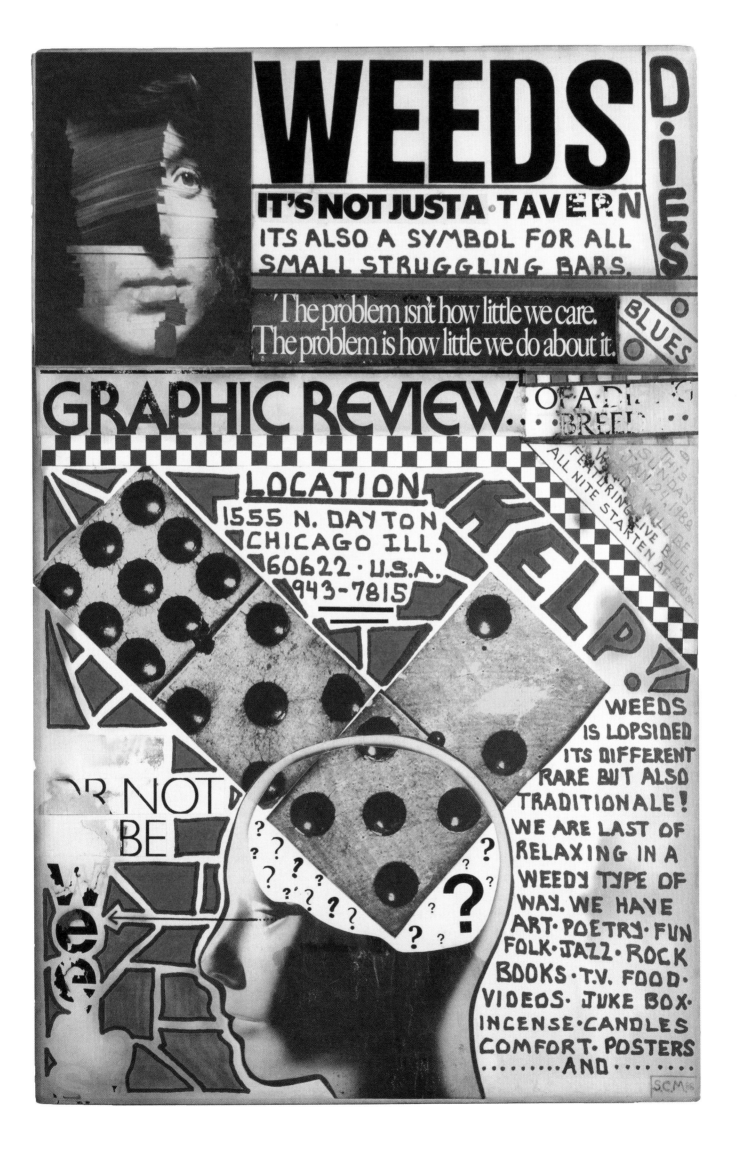

**I messed up at Weeds,
now I'm doing time barred!**

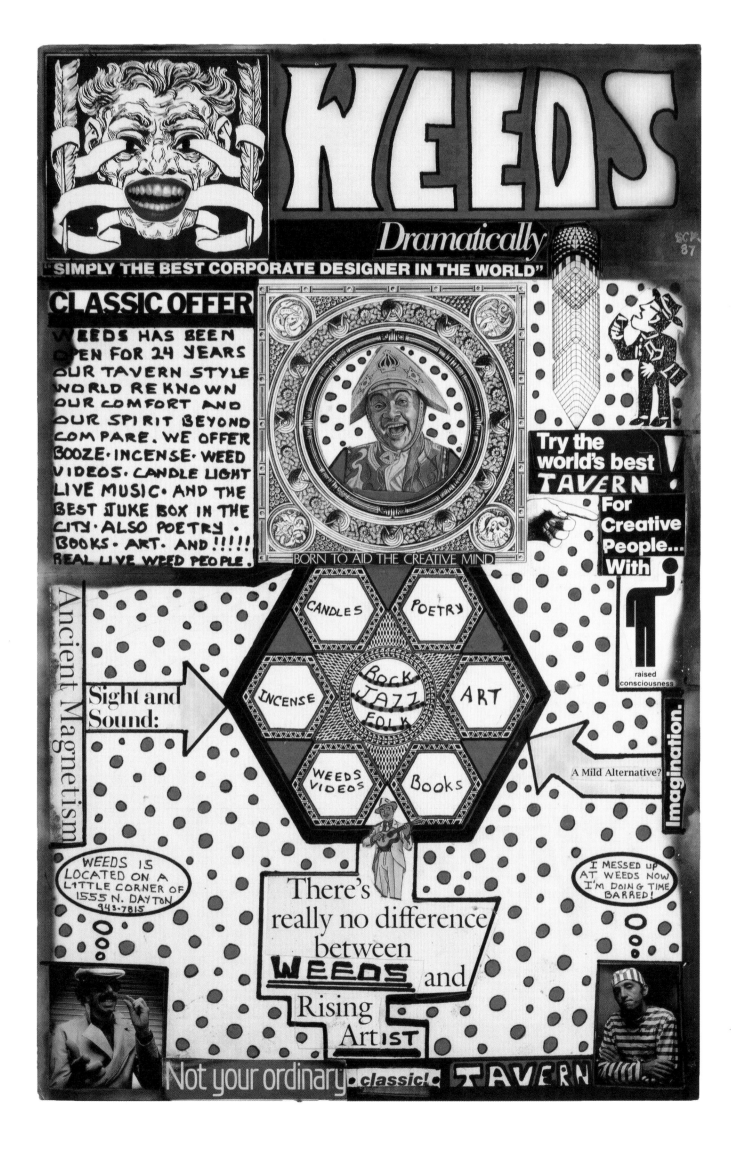

WEEDS

ESTᴰ
SINCE
1963

**Transcending the limits of
legendary history making.**

WEEDS!

SCM 88.

is
Going to
Change Your
Thinking
About

TRANSCENDING THE LIMITS

of

LEGENDRY

History Making

WIDE!
Communication
Images
HOW?

1555 N. DAYTON
CHICAGO ILLINIOS
60622 U.S.A.
943-7815

weedS ←

SINCE WE ARE A VERY SMALL CORNER TAVERN ONE OF 1000s IN CHICAGO AND ONE OF MILLIONS IN THE WORLD AND THE FACT THAT WEEDS TAVERN DOESEN'T DO ANY PAID ADVERTISMENT + THE FACT THAT EXCEPT FOR WORD OF MOUTH AND A FEW LUCKY NEWS PAPER STORIES WE ARE STILL SO WELL KNOWN IN THE WORLD, CONSIDERING WERE JUST A BAR IT SEEMS A BIT LUCKY, BUT IT IS

NOT LUCK JUST COMMON SENSE WE MAKE POSTERS SOME GOOD SOME VERY BAD AND WE HAVE BEEN SENDING DISTRIBUTING THEM TO AT LEAST 15 DIFFERENT COUNTRIES FOR THE LAST 3 YEARS THAT IS WHY NOW AFTER ALL THIS WE NOW HAVE ON EVERY DAY OF THE WEEK TOURIST FROM ALL OVER AMERICA AND THE WORLD STOPPING IN FOR A DRINK IF THEY HAPPEN TO BE IN CHICAGO. YOUR BUISNESS CAN DO THE SAME ITS FUN EASY AND CHEAP!

Come in and get your shot of
one of the best and also the
longest, still knocking em
down open mikes in the city
of this supergreat Chicago.

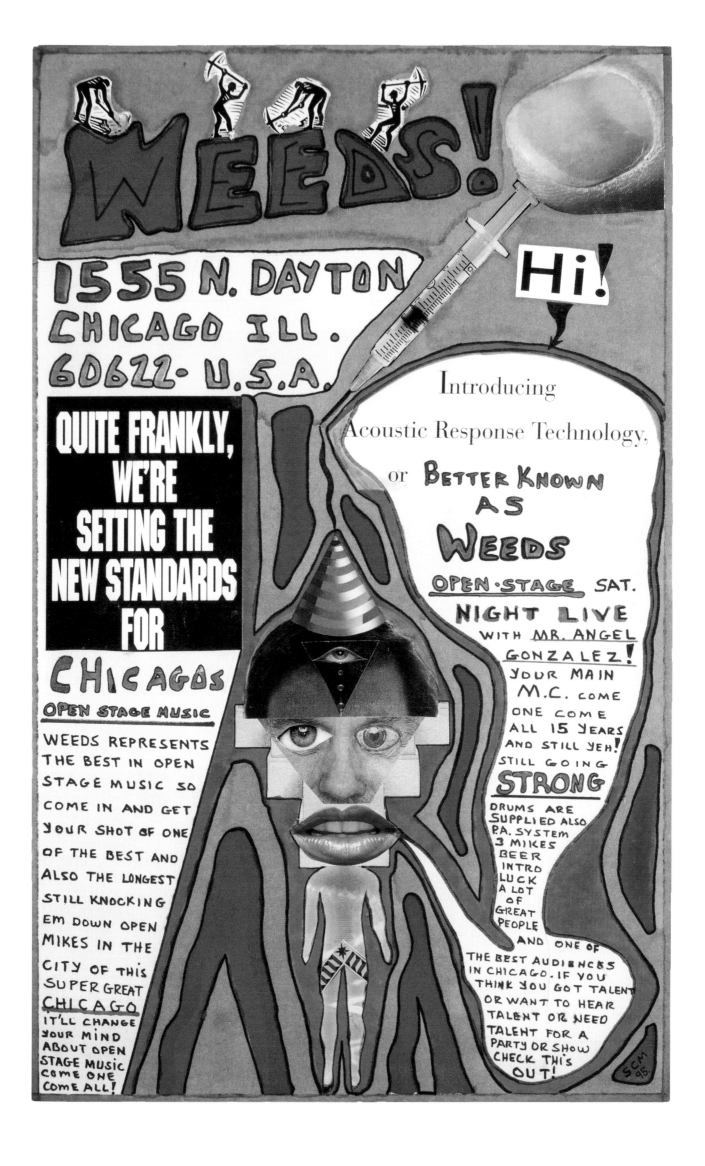

WEEDS

ESTD
SINCE
1963

A Chicago tradition as American as the Alamo.

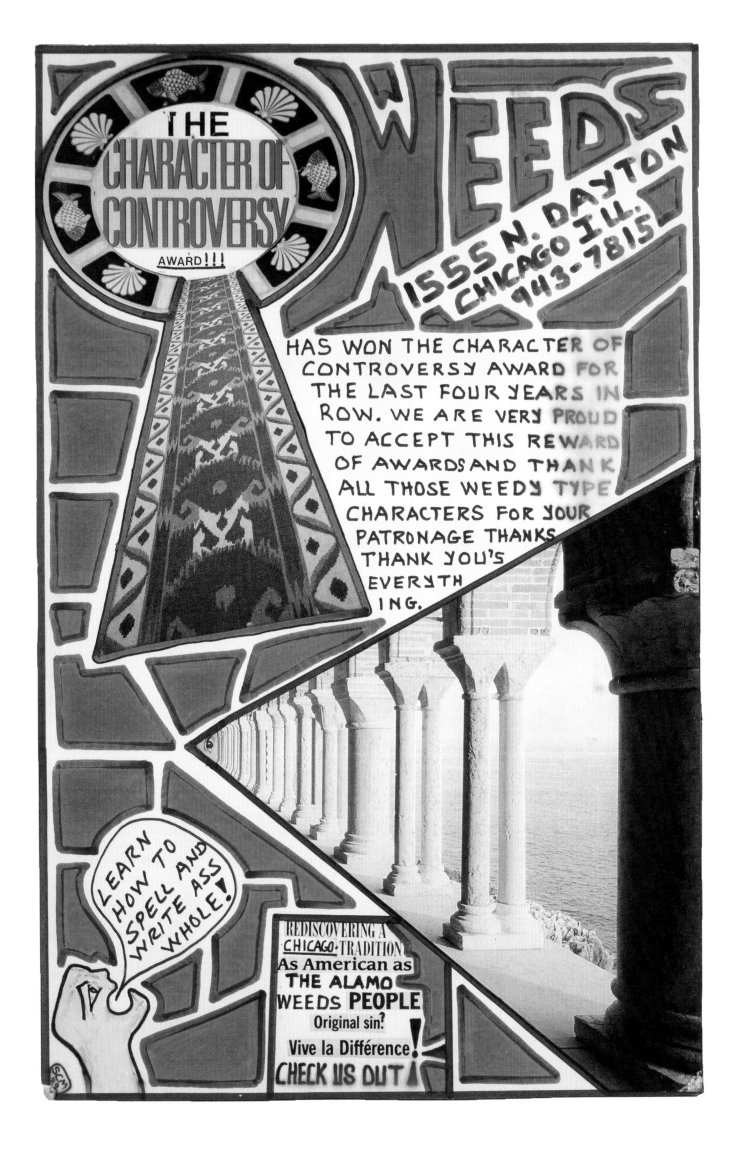

At last, a bar for
individuals who'd never
dream of entering one.
We'll grow on you.

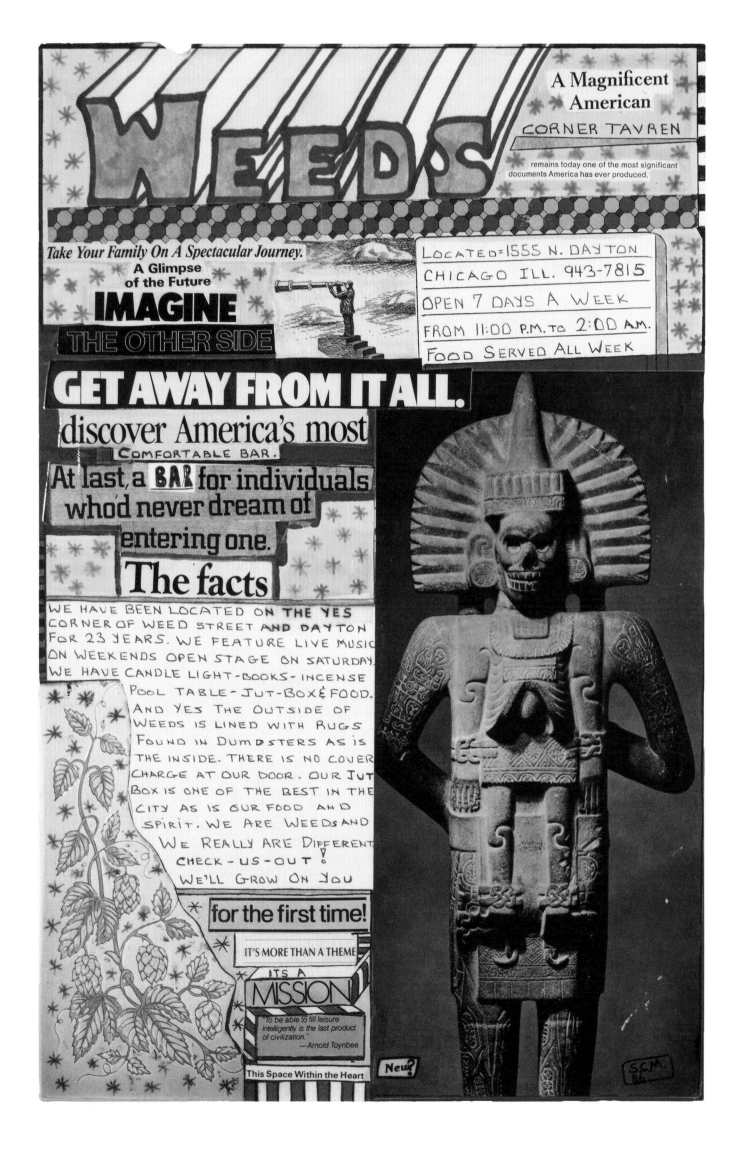

WEEDS

ESTD
SINCE
1963

I was a crazy!
Before I became a Weed person.
Honest.

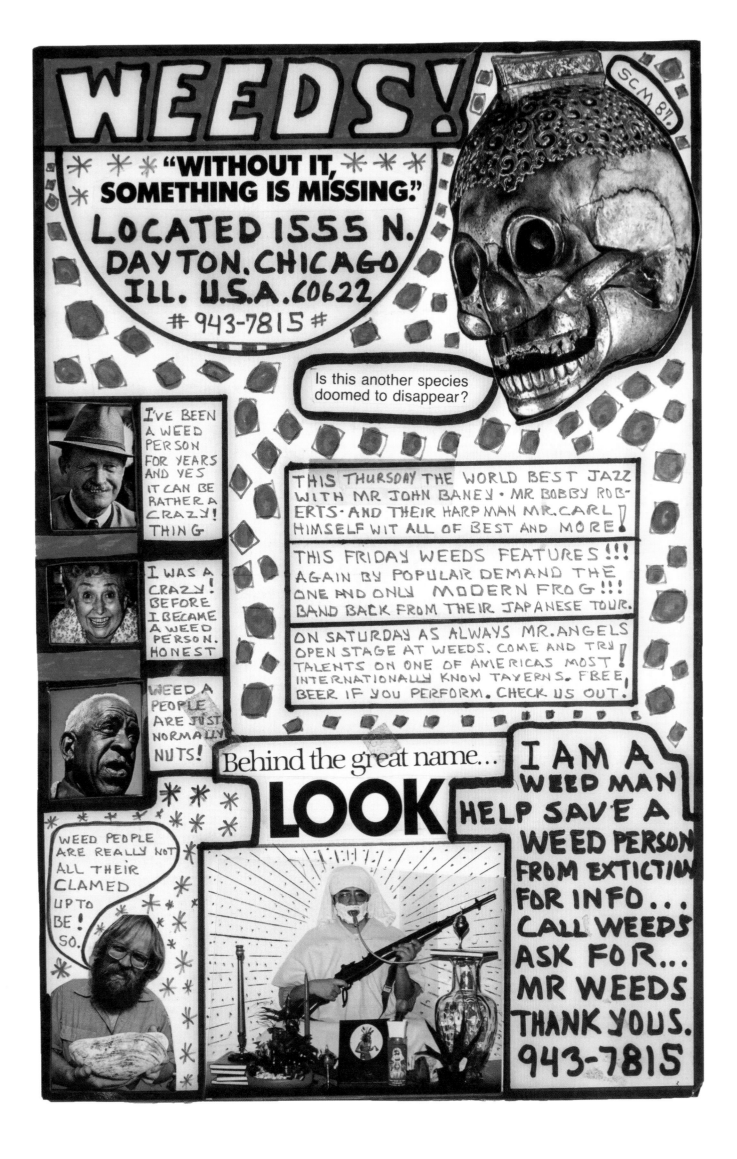

Sergio Mayora is an artist, poet, singer-songwriter, and actor. The long-time bartender and host at Chicago's iconic Weeds Tavern, Sergio became well-known for creating his collage posters to promote the club. Commissioned by Willie Dixon's Blues Heaven Foundation to make a four-plate spirit box for Carlos Santana, his work has been shown at the Ukrainian Institute of Modern Art, the Citlalin Gallery Theater and the INTUIT (The Center for Intuitive and Outsider Art) gallery in Chicago.

Dave Hoekstra is a Chicago author-journalist. From 1985 through 2014, he was a columnist-critic at the *Chicago Sun-Times*, where he won the 2013 Studs Terkel Community Media Award. He has contributed pieces to the *Chicago Reader*, *New City*, and *Raw Vision*. He has written several books, including *Beacons in the Darkness: Hope and Transformation Among America's Community Newspapers*, *The Supper Club Book: A Celebration of a Midwest Tradition*, and *The People's Place: Soul Food Restaurants and Reminiscences from The Civil Rights Era to Today*. Dave wrote and co-produced the WTTW-Channel 11 PBS special, "The Staple Singers and the Civil Rights Movement," nominated for a 2001–02 Chicago Emmy for Outstanding Achievement for a Documentary Program. He also wrote and co-produced the award-winning 2018 full-length documentary and companion book *The Center of Nowhere: The Spirit and Sounds of Springfield, Missouri*.

© 2023 Trope Industries LLC.

This book and any portion thereof
may not be reproduced or used in
any manner whatsoever without the
express written permission of the
publisher. All rights reserved.

© 2023 Posters by Sergio Mayora
© 2023 Text by Dave Hoekstra

LCCN: 2023908941
ISBN: 978-1-951963-19-4

Printed and bound in China
First printing, 2023

**For additional information
on our books and prints,
visit trope.com**